D1268481

JAN 2 3 2008

6-8-12(7)

GREAT AMERICAN BILLBOARDS

100 Years of History by the Side of the Road

FRED E. BASTEN

TEN SPEED PRESS

Berkeley | Toronto

Indian Prairie Public Library District
401 Plainfield Road ~ Darien, IL 60561

Copyright © 2007 by Fred E. Basten. All rights reserved. No part of this book may be reproduced in any form, except brief excerpts for review, without the written permission of the publisher.

Ten Speed Press
PO Box 7123
Berkeley CA 94707
www.tenspeed.com

Distributed in Australia by Simon and Schuster Australia, in Canada by Ten Speed Press Canada, in New Zealand by Southern Publishers Group, in South Africa by Real Books, and in the United Kingdom and Europe by Publishers Group UK.

In addition to the scores of great American billboards from the archives of Foster and Kleiser, selected photos were generously provided by Rob Medina (Chicago History Museum), Tama Starr (Artkraft Strauss), Robert Landau, and Season Skuro.

Cover and interior design by Betsy Stromberg

Library of Congress Cataloging-in-Publication Data on file with the publisher.

First printing, 2007

Printed in China

1 2 3 4 5 6 7 8 9 10 – 10 09 08 07

Preface

This book had its beginnings in 1995 during a luncheon in Burbank, California, when my good friend Lillian Michelson, who runs the research library at DreamWorks Studio, introduced me to Joe Blackstock, the historian at Foster and Kleiser. Joe started at the renowned outdoor advertising company in 1940 as the personal chauffeur to Mr. Foster and Mr. Kleiser, and worked his way up through various departments, including sales, marketing, and research. In 1995, he took on the role of company historian. The archive comprises the most complete collection of American outdoor advertising memorabilia ever assembled, and was subsequently named in his honor.

It was Joe's idea to do a book drawn from the Foster and Kleiser archives, and I was sold even before he asked. I could sense Joe's pride in the collection. Preserving history was his goal. Mine, too. Previous commitments conspired against us until the summer of 1998 when, as Joe was celebrating his 58th anniversary with the company, the project finally got underway.

The Joe Blackstock Archive was housed in a huge room lined with file cabinets and shelves overflowing with a century's worth of material categorized by subject. "Take what you want," he said, "and take your time." I did, as it was impossible to go through the entire collection in one session. Four or five more followed, stretching into the fall months. At each get together, Joe and I talked for hours about the art of public persuasion.

The research for this book took considerably longer than expected. When it came time to contact Joe Blackstock with news of my progress, I learned that he had passed away not many months after our last meeting. I thought of him every time I studied one of his prized billboards—they were so much a part of Joe's life. I hope this book is a fitting tribute to his inspiration.

—Fred E. Basten, Los Angeles, 2007

Contents

Introduction • 1

Chapter 1 • 10
Along America's Railways & Roadways
(1900–1917)

Chapter 2 • 22
A World at War (1917–1918)

Chapter 3 • 30
A Stylish New Beginning (1920–1929)

Chapter 4 • 48
Uplifting Depression Spirits (1930–1939)

Chapter 5 • 72
Uncertain Times (The Pre-War 1940s)

Chapter 6 • 88
A Nation United (1942–1943)

Chapter 7 • 114
A Celebration (1944–1949)

Chapter 8 • 128
Outdoor Advertising Grows Up (1950–1959)

Chapter 9 • 148
New Concerns, New Attitudes (1960–1969)

Chapter 10 • 172
Reawakening & Transition (1970–1979)

Chapter 11 • 194
Bigger, Brighter, Bolder (1980–1989)

Chapter 12 • 206
A New Era Begins (1990–1999)

Afterword • 217

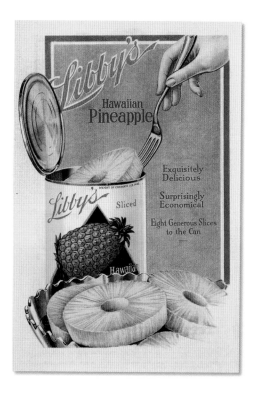

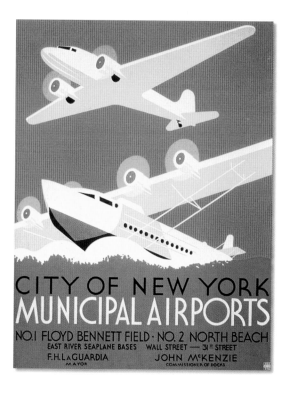

Libby's Hawaiian Pineapple, poster, 1916.

City of New York Municipal Airports, poster, 1937.

Foster and Kleiser horse-drawn posting wagon, 1910.

Posting wagons contained everything needed to post one-sheet and multi-sheet signs, including the folded posters, adhesives, and brushes.

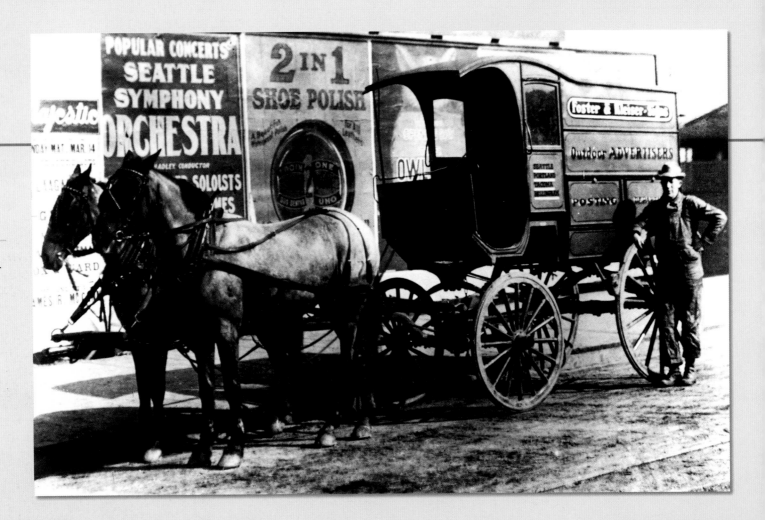

Introduction

Neolithic cave paintings in Spain and France bear the unmistakable images of animals standing, running, alone, or in herds. What was the message? Were they a warning to alert early humans to the dangers lurking outside, or an announcement of the riches waiting beyond the cave walls?

Nearly four thousand years ago, hieroglyphic characters were cut into stone tablets and obelisks by enterprising Egyptian merchants to be seen by a busy passing public. Several centuries later, ancient Greek bureaucrats incised wood-encased columns to announce the order of public games. Throughout Pompeii, frescoed walls bearing political propaganda (some serious, some satirical) survived the eruption of Mt. Vesuvius in 79 A. D.

It is clear that matters of trade, entertainment, sporting events, and politics have been "advertised" in virtually all cultures the world over. Making information available to potential customers about merchandise, to loyal fans about athletic spectacles, and to citizens about the breaking political scene was as important historically as it is today.

And what better way to reach as many people as possible than by advertising outdoors for all to see?

From early Mediterranean beginnings, the practice of posting bills and broadsides (single imprinted sheets) began to spread northward into Europe and Britain. By the mid-1400s, handbills were being posted wherever people gathered, on church doors, outside guild halls, and in village squares.

The process of hand-lettering each poster, no matter the size, was laborious, time-consuming, and costly. But the invention of the printing press by Johan Guttenberg in 1456 changed all that. Over the next century it became possible to produce multiple copies with the turn of a crank. Another advance came in the late 1700s with the invention of lithography. This process not only made multiple printed impressions, it made artistic designs, and even color, available.

Across the Atlantic in the American colonies, billposting became an extremely popular method of purveying information. And because

literacy was not widespread, illustrated broadsides became the key to reaching an eager public. An artisan's trade and a merchant's wares were more quickly identified by pictorial symbols than by names or written descriptions. So it was not unusual to see, for example, a wooden sign carved or painted with the image of horse hanging outside a livery stable.

With the Industrial Revolution, mechanization began to replace hand labor. Lithography became automated and made the production of oversized handbills—posters—possible. The nineteenth century was a technological age that saw many innovations in printing, including equipment that could cut the paper to size and fold the stock for easy storage and handling by the traveling billposters.

Billposting on any available vertical space became so prevalent that by 1850 firms that promised "responsible posting services" were being founded. The first outdoor advertising association followed in 1875, but had little effect due to the lack of signage laws. The great outdoors had become a wide-open canvas that allowed anyone to post a sign wherever they wanted, even over another sign. This dubious practice led to the leasing of a prescribed space, such as the side of a barn or commercial building, for a specific time period, from the building's owner. Not surprisingly, this in turn led to the formation of ad companies that specialized in brokering such agreements. Buildings that fronted railway stations or busy mercantile districts were especially coveted.

Particularly innovative in the area of outdoor advertising were America's traveling circuses. From the mid-nineteenth through the mid-twentieth centuries, the arrival of a circus in town was preceded by a flood of posters blanketing not only every available vertical wall, fence, and barn-side, but virtually anything that moved: wagons, carriages, bicycles, and later trains, streetcars, buses, and automobiles. The design of the posters, the images selected, and the colors used evolved to according to the speed at which a passersby (a potential patron) traveled. Thus, earliest postings tended to be richly detailed, the assumption being that the viewer was on foot or horseback and had the time to stop and study the poster. But as roads improved, public transport proliferated, and car ownership became affordable, the speed of travel increased, and viewing time became more limited. Thus, the images had to became bigger, bolder, brighter, and more stylized.

The nineteenth-century one-sheet poster measured, on average, 28 x 42 inches. Lining up three posters contiguously to create a single large image was known as a three-sheet poster and usually totaled 42 x 84 inches. (By contrast, the twenty-four-sheet poster would become the standard, measuring 8 feet, 8 inches x 19 feet, 6 inches.) In locations where available display space was already monopolized, local lumberyards sold cheap wooden boards to desperate advertisers who erected temporary fencing in vacant lots or along railway sidings on which to post their bills. It wasn't long before the term "billboard" was used for this dedicated, freestanding signage.

American architects revolutionized the urban landscape, and introduced another new word to the vernacular: skyscraper. The nation's (and the world's) first skyscraper, went up in Chicago in 1885. Although only ten stories high, it was the harbinger of a vertical trend made possible thanks to a new contraption: the elevator.

Signage was developed to take advantage of these towering exteriors and lofty rooftops as occupants of the new high-rises provided a fresh audience for advertisers.

By the 1920s, more Americans were climbing into their affordable new Model-Ts and taking to the open road—and manufacturers and retailers saw miles and miles of untapped promotional potential stretch before them to the horizon.

In postwar America, with the demise of the railway and the rise of the freeway, the audaciously oversized American billboard truly came into its own. And it has recruited, congratulated, sold, seduced, teased, and promoted everything under the sun—literally—ever since.

Early in the twentieth century, a prophetic advertising executive wrote: "Historians of the future will not have to pore over obscure documents and ancient prints to reconstruct a faithful record of our times. Day by day, that picture is recorded completely and vividly in American advertising, producing for future generations the action, color, variety, dignity, and aspirations of the American scene."

The Largest Picture in the World, wallscape, 1895.

The wallscape was a precursor to the freestanding billboard and was painted directly onto the side or back wall of a building. The Wilson Whiskey advertisement appeared near Madison Street and Wabash Avenue, Chicago. Only half of the wall is shown here, but the heights of the items illustrated were listed which, along with the windows, gave the viewer a breath-taking sense of scale.

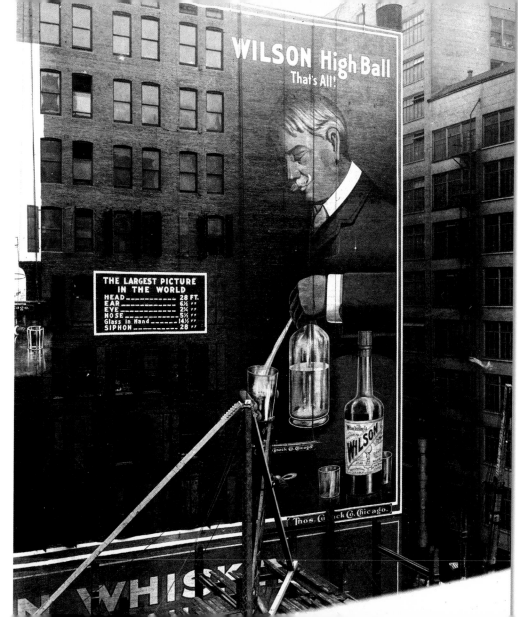

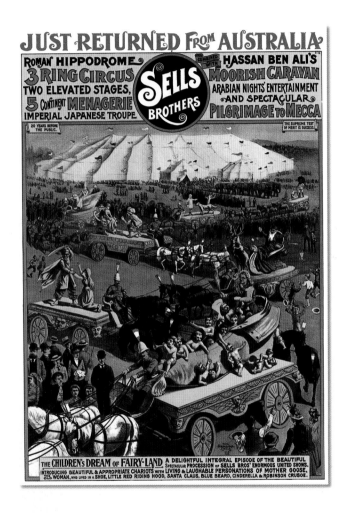

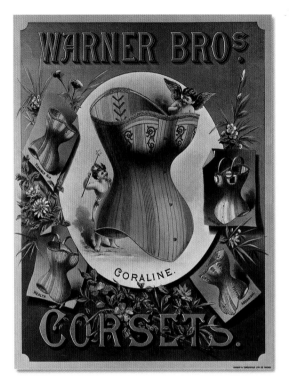

Warner Bros. Corsets, poster, 1898.

The advertisement boldly illustrated its products instead of relying on descriptive text. Each model was assigned a name that suggested its practical differences from the other styles.

☞ **Sells Brothers Circus, poster, 1893.**

Because this poster was intended to seen up close by pedestrian traffic, there is an exceptional level of complexity and detail in the design and typography.

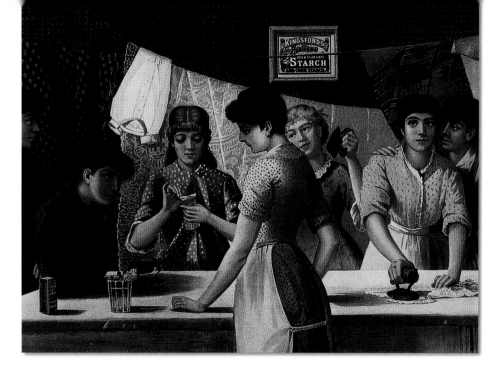

Kingsford's Starch, poster, late 1890s.

In this narrative approach, a gathering of women at an ironing table would seem to dominate the scene, although the eye is continually drawn to the small sign just off-center in the background.

American Brewing Company of Boston, poster, late 1890s. ☞

Aimed at A.B.C.'s primary demographic: Irish, Italian, and German immigrants, nostalgic for the old country. Brewery employees often served as models in many of the company's early promotions.

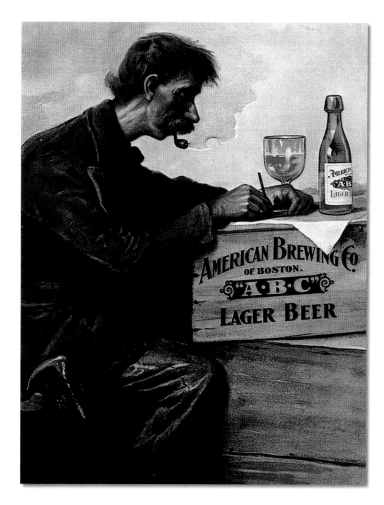

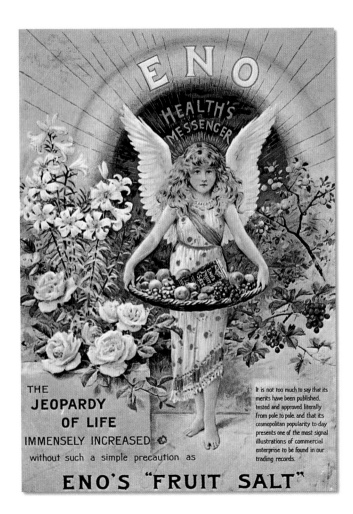

THE
JEOPARDY
OF LIFE
IMMENSELY INCREASED
without such a simple precaution as
ENO'S "FRUIT SALT"

It is not too much to say that its merits have been published, tested and approved literally from pole to pole, and that its cosmopolitan popularity to-day presents one of the most signal illustrations of commercial enterprise to be found in our trading records.

Bovril, poster, 1899. ☞

Created by Scotsman John Lawson Johnston in the 1870s with the unappetizing brand name of Johnston's Fluid Beef, the product was re-christened with the compound: *bos,* Latin for beef, and *vril,* an "electric" fluid. Promoted as a health drink, its wholesomeness is epitomized by the pretty nurse, and further emphasized by the ad copy.

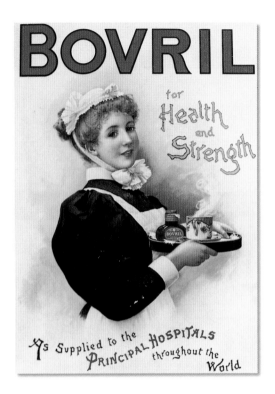

Eno's Fruit Salt, poster, 1897.

The romantic and richly detailed style of illustration was typical of the period. But the long paragraph of promotional copy fails to mention the actual purpose or merits of the product (a laxative).

Typical billboard fence, Portland, 1901.

U.S. Army recruiting poster (left) is an example of the three-sheet poster, in which three 28 x 42-inch posters are lined up contiguously to form a single large image.

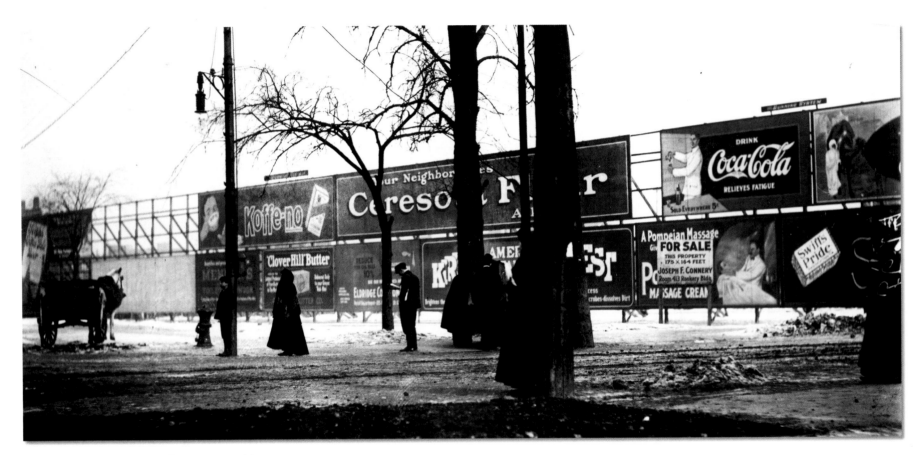

Cottage Grove Avenue, Chicago, 1908.

Against a backdrop of freestanding billboards, passengers await a streetcar.

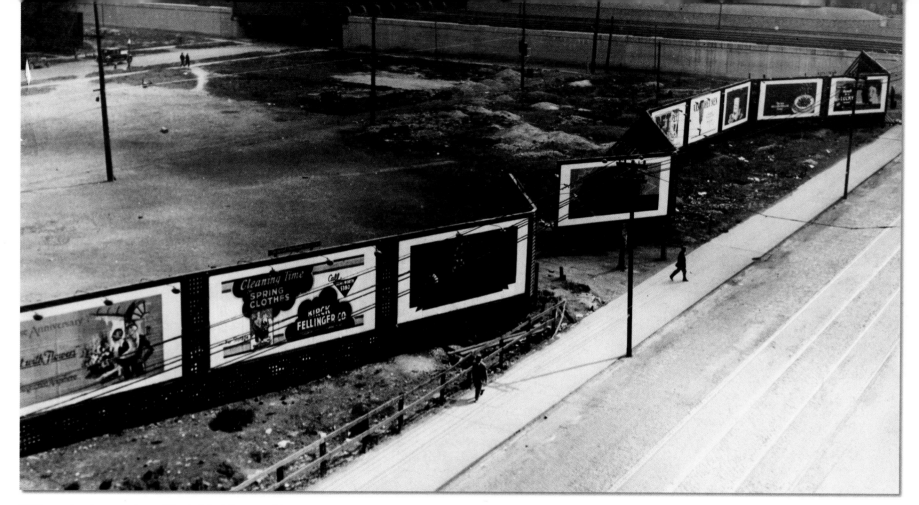

Billboards zigzag along West 63rd Street, Chicago, 1914.

These examples beside an empty field are angled for the greatest visual impact.

1900—1917

Along America's Railways & Roadways

America in the nineteenth century was primarily a nation of farmers, and, for countless communities, it was the railroad that made the difference between isolation and poverty or growth and prosperity. In 1869, the country was finally connected, east and west, coast to coast, when its first transcontinental railroad was completed, and the tracks of the Union Pacific met those of the Central Pacific at Promontory, Utah.

By 1900, nearly 200,000 miles of track had been laid to serve cities, towns, and rural communities. As the new century dawned, nearly all Americans who traveled did so by train. So it was no surprise that the railroad yards around every city and town had become popular locations for posting promotional materials, as this was where trains moved slowly enough for passengers to get a good look at a sign. In fact, many advertisers of the day were changing the way they pitched their products in order to take advantage of this expanding audience. For example, Coca-Cola, which started as a medicinal tonic, was no longer touted as an adult headache curative, but was instead promoted as a tasty, refreshing booster that was appealing and appropriate to all ages.

Small businesses became big companies, which merged and consolidated into large corporations. These growing entities had comparatively enormous budgets to spend on the advertising and promotion of their goods and services.

And more change was on the horizon. The so-called horseless carriage had already been introduced by 1900, but motorcars were primarily for the privileged few. (A Pierce-Arrow sold for a staggering $4,000.) And with fewer than 150 miles of paved roads in the U.S., there weren't many places to drive. In 1908, Henry Ford introduced his Model T, which sold for the comparatively modest sum of $850. By 1914, with demand far exceeding production, Ford introduced the world's first automobile assembly line at his Detroit plant. This innovation revolutionized modern American industry—and it cut the Ts' selling price in half. Within a year, half of all new cars sold were Model Ts.

In 1903, as his brother watched, Orville Wright made the first airplane flight off Kill Devil Hill over the dunes of Kitty Hawk, North Carolina. There were 1.3 million telephones in service. And even the fashions of the period were moving from the stiff Victorian formality to the softer, though still corseted, look of the "Gibson Girl," created by American illustrator Charles Dana Gibson. The Gibson Girl was an idealized image that represented new ideas about how women were perceived and, perhaps more important, how women perceived themselves: beautiful but emancipated, desired but independent, athletic but feminine—and every American girl wanted to copy her.

Entertainment for most Americans meant going out to the music halls, where many future Broadway, radio, and film stars began their careers honing their skills on vaudeville stages across the country. The earliest movies were known as nickelodeons, as admission was 5 cents for a show that lasted about 30 minutes. Shown in makeshift theaters converted from small storefronts, audiences sat on folding chairs as a piano player accompanied the silent one-reel films. By 1908, nearly 10 thousand nickelodeons were operating nationwide with roughly 80 million tickets sold each week.

As the decade progressed, moviemakers headed west where the weather was more conducive to outdoor filming. They settled on the outskirts of Los Angeles, in an area planted with orange groves called Hollywood. Longer, multi-reel films with larger casts replaced the single-reel shorts, and the once anonymous players became household names, like Mary Pickford, Charlie Chaplin, Douglas Fairbanks, Harold Lloyd and Buster Keaton. Movie studios used billboard advertising along America's railways and roadways to promote their latest releases and newest stars.

Between 1900 and 1910 an estimated 10 million immigrants, at the rate of 1 million per year, arrived from Europe. With the passage of Jim Crow laws, racism was intensifying in the South, forcing large numbers of blacks to migrate to already crowded northern cities like Chicago, Detroit, Philadelphia, Cleveland, and New York, in the hope of finding work.

Growing unrest in Europe found most Americans looking the other way. They were preoccupied with professional sports like baseball; they played a new game called bridge; and they shopped at the new general stores, called dime stores. They dreamed over mail order catalogs, called wish lists, from Sears and Roebuck and L. L. Bean; they chuckled over the funnies, a daily addition of comic strips to many newspapers; they took pictures with their newly portable Brownie cameras; they danced the Castle Walk, made famous by Irene and Vernon Castle. But by 1914, Europe was at war, and storm clouds were already gathering on America's horizon, no matter how they tried to ignore them.

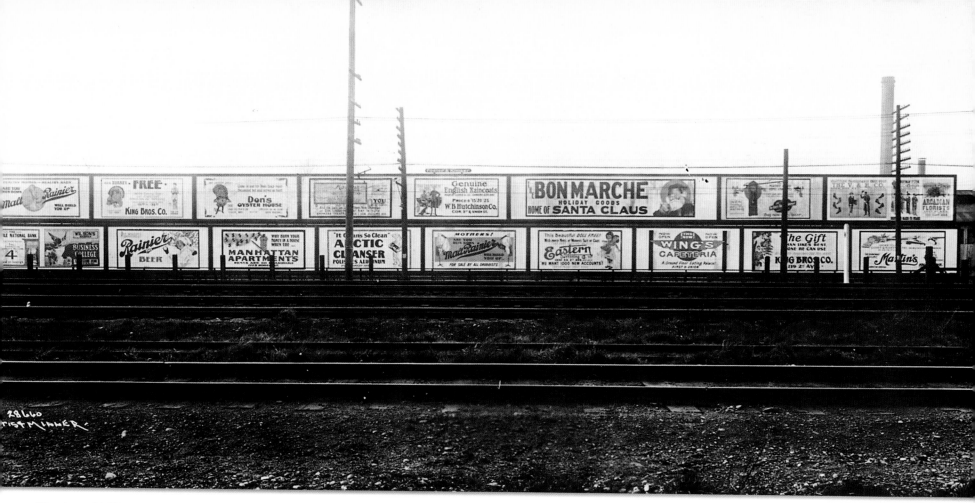

Cluster of billboards along a railroad siding, 1900.

Manufacturers hoped to capture the attention of travelers as their trains arrived and departed.

Coca-Cola, poster, 1904.

Developed in 1886 by an Atlanta pharmacist as a headache remedy, Coca-Cola gained far greater popularity as a refreshment. The celebrity spokesperson was a popular marketing gambit, and from 1903 to 1905, the favorite Coca-Cola model was Lillian Nordica, diva of the Metropolitan opera.

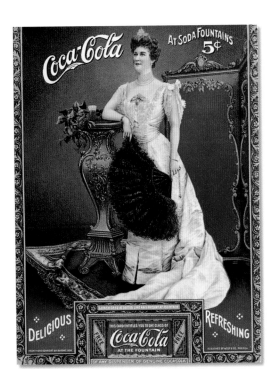

Gold Medal Flour, poster, 1906. ☞

In 1880, Washburn-Crosby's finest grade flour, called Superlative, won the gold medal at the first Miller's International Exposition in Cincinnati. Superlative Flour was quickly renamed Gold Medal Flour, a brand still popular today. (A merger in 1928 launched cereal giant General Mills.) Instead of using a celebrity to promote the product, an idealized image of the typical consumer was created.

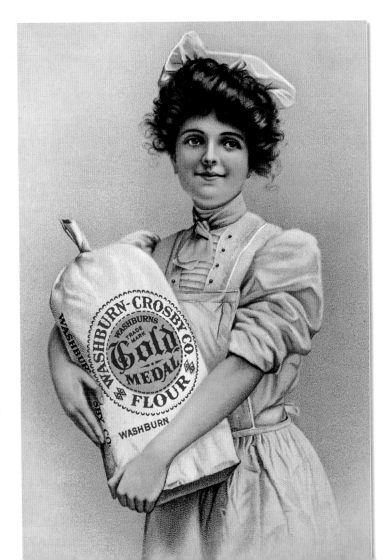

Genuine Bull Durham, poster, 1908.

Enormous painted displays featuring the bovine mascot, some as large as 25 feet high, appeared in ballparks across America. In those days, all pro ball games were played during daylight hours, and often in humid summer weather. Relief pitchers warming up for duty often chose to do so in the shade of the big Bull Durham boards. This warm-up area eventually came to be known as the "bullpen."

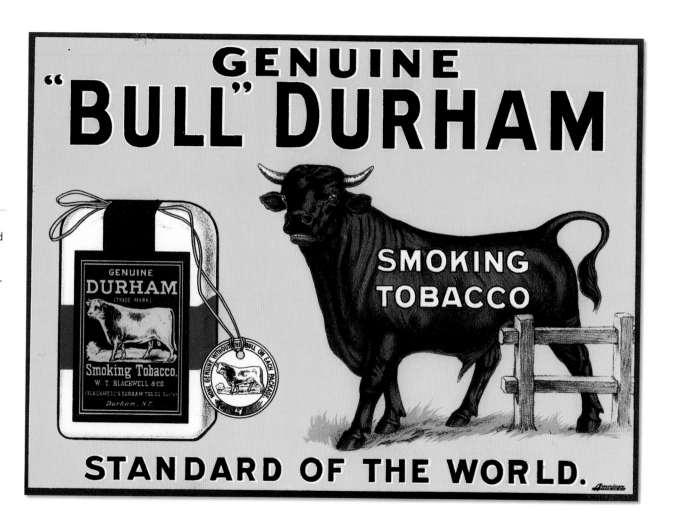

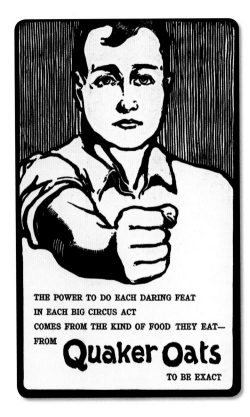

☞ Quaker Oats, poster, 1910.

In contrast, the audience for this poster was the labor-driven workforce. Here, the many uses of oats (breads, cereals, biscuits) have been not been mentioned, nor is the product itself shown. Instead, the domestic consumer is meant to identify with a high-performance professional. The starkness of the image, the foreshortened prospective of the figure, and the woodcut style of illustration recall the political posters of the era and are a sharp contrast to the romantic realism used in Gold Medal Flour (page 14).

Pierce Arrow, poster, 1907.

Pierce Arrow identified its customers as wealthy, urban socialites in its earliest ads. Compare this poster with the Chevrolet billboard from 1950 that targeted a middle-class, family-oriented audience (page 132).

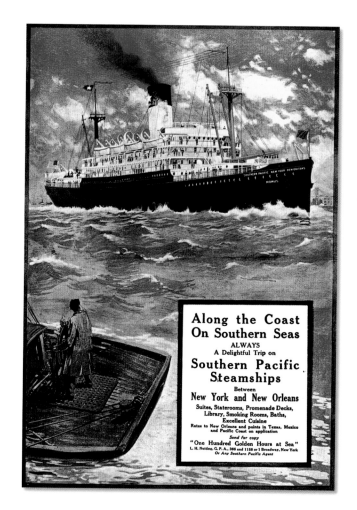

Along the Coast
On Southern Seas
ALWAYS
A Delightful Trip on
Southern Pacific
Steamships
Between
New York and New Orleans
Suites, Staterooms, Promenade Decks,
Library, Smoking Rooms, Baths,
Excellent Cuisine
Rates to New Orleans and points in Texas, Mexico
and Pacific Coast on application
Send for copy
"One Hundred Golden Hours at Sea"
L. H. Nutting, G. P. A., 366 and 1158 or 1 Broadway, New York
Or Any Southern Pacific Agent

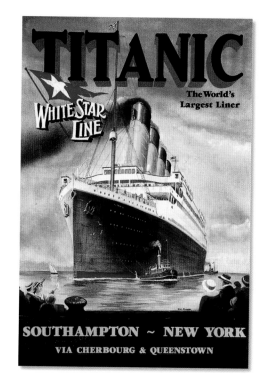

Titanic, poster, 1912.

When R.M.S. *Titanic* departed from Southampton, England, on April 10, 1912, her maiden voyage made headlines. Believed to be unsinkable, four days later she made headlines again as the largest maritime disaster in history when she sank with 1,529 souls on board in an ice field off the Greenland coast. Among the 705 survivors was the ship's designer, Arthur Isme.

Southern Pacific Steamships, poster, 1910.

A trans-Atlantic crossing was too expensive for most Americans. But coastal cruising aboard a smaller vessel, like the Southern Pacific's *Nomas,* was more affordable.

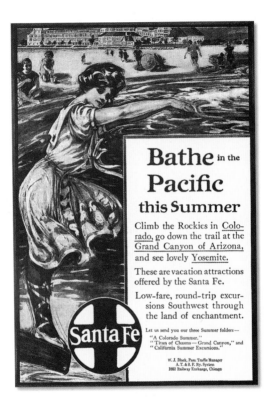

Bathe in the
Pacific
this Summer

Climb the Rockies in Colo-
rado, go down the trail at the
Grand Canyon of Arizona,
and see lovely Yosemite.

These are vacation attractions
offered by the Santa Fe.

Low-fare, round-trip excur-
sions Southwest through
the land of enchantment.

Let us send you our three Summer folders—
"A Colorado Summer,"
"Titan of Chasms — Grand Canyon," and
"California Summer Excursions."

W. J. Black, Pass. Traffic Manager
A. T. & S. F. Ry. System
1002 Railway Exchange, Chicago

Bathe in the Pacific, poster, 1914.

Go west, as far west as possible by train, was the enticing theme for the summer of
'14. Unlike the steamship companies that proudly displayed portraits of their liners,
there isn't a train to be found on this poster. Instead, a flirtatious bathing beauty awaits
passengers at the end of the line.

Onyx Silk Hosiery, ☞
poster, 1915.

The direct gaze and playful sexi-
ness of another bathing beauty
was an idealized rendering of the
Onyx customer and owes much
to the Gibson Girl aesthetic that
swept American advertising from
1900 to 1920.

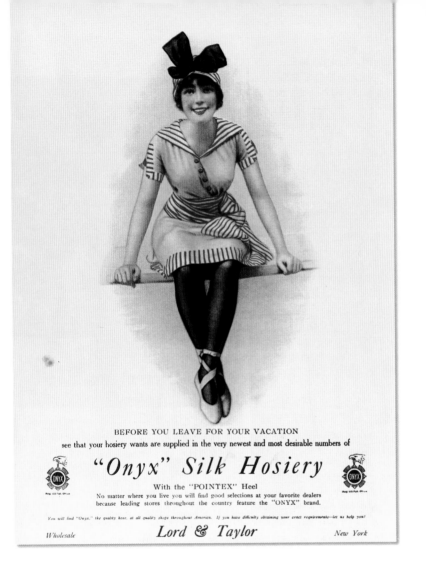

BEFORE YOU LEAVE FOR YOUR VACATION
see that your hosiery wants are supplied in the very newest and most desirable numbers of

"Onyx" Silk Hosiery

With the "POINTEX" Heel
No matter where you live you will find good selections at your favorite dealers
because leading stores throughout the country feature the "ONYX" brand.

You will find "Onyx," the quality hose, at all quality shops throughout America. If you have difficulty obtaining your exact requirements—let us help you!

Wholesale *Lord & Taylor* New York

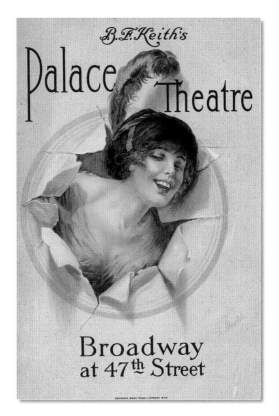

Palace Theatre, poster, 1914.

This dynamic graphic did not promote a specific star or current production, rather, it promoted the theater itself as a destination. Over the next few years, New York would become the show business capital of America, thanks to theaters like the Palace.

Murad, The Turkish Cigarette, ☞
poster, 1915.

The sophisticated sensuality of the Murad woman was modeled on the elegant illustrations by Charles Dana Gibson whose famously provocative Gibson Girls had enormous impact not only on advertising, but social attitudes of the day.

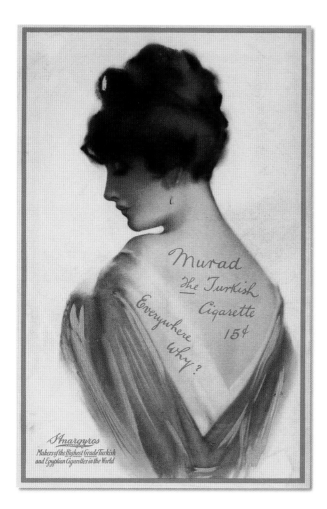

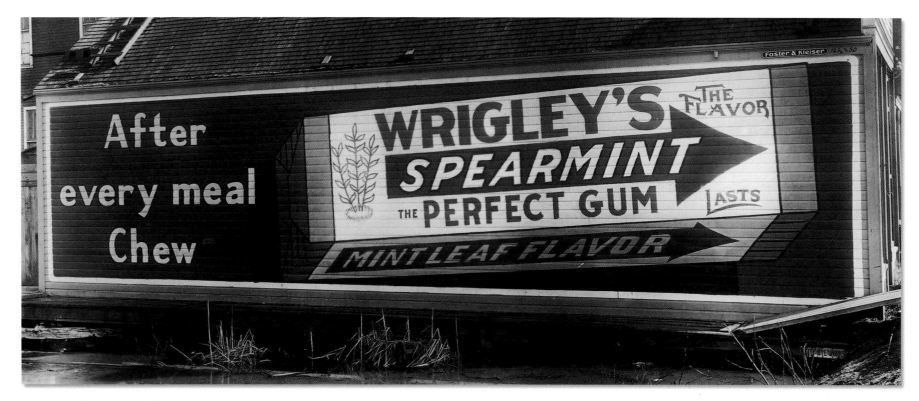

Wrigley's Spearmint Gum, 1916.

Sides of barns, warehouses, even roofs were typical locations for painted billboards. This elongated display on Puyallup Avenue in Tacoma takes full advantage of the building's broad side and shows the Wrigley product to great advantage. Both Spearmint and Juicy Fruit flavors had been introduced in 1893.

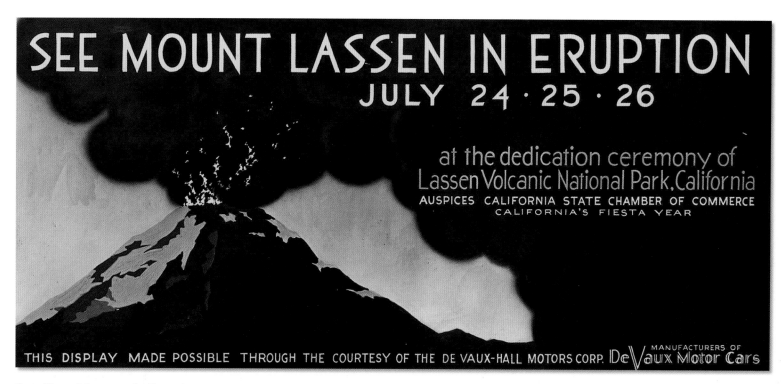

See Mount Lassen in Eruption, 1916.

In May 1914, Lassen Peak began a series of violent eruptions. The southernmost volcano in the Cascade Range, Mount Lassen became an instant tourist attraction, and was dedicated Lassen Volcanic National Park in 1916. It is an interesting feature of this billboard that the sponsor was a car manufacturer and not a railway, a testimony to the growing interest in and importance of automobile travel.

1917—1918

A World at War

The assassinations of Archduke Ferdinand, heir apparent to the Austro-Hungarian Empire, and his wife Sophia, were at first thought to be only a regional incident with no international repercussions. President Woodrow Wilson had even remarked, rather callously, that the killings were "nothing in particular." But, within months Austria-Hungary's ally Germany had declared war on Russia, France, and Belgium. Britain declared war on Germany and "a war to end all wars," a phrase coined by famed British author writer H. G. Wells, was underway.

Most Americans believed the turmoil in Europe would soon end. President Wilson stressed neutrality during his 1916 reelection campaign, proclaiming "we must remain impartial in thought as well as in action." Posters touted Wilson as the leader "who keeps us out of war." But German submarines, called U-boats (short for *Unterseeboots*), were massing in the North Atlantic. The sinking of the British luxury liner *Lusitania* by a German U-boat in British waters had cost 1,198 lives, including 128 Americans.

Even closer to home, Germany was waging a secret war within the United States by inciting labor unrest and planting explosives aboard supply ships headed for America's allies. When New York harbor was rocked for six hours by over two million pounds of munitions, it was believed to be the work of German sabateurs. Before long, the United States, too, was at war.

America's entry into World War I in April 1917 was neither unexpected nor unpopular. Allied nations welcomed fresh reinforcements as the war expanded from the muddy trenches of Europe to Turkey and the deserts of Africa. While some Americans were already volunteering to help Allies overseas, the government urgently needed a way to enthusiastically mobilize a reluctant public.

Although radio technology had been developed prior to the war, experimental broadcasting was limited, leaving newspapers, magazines, and newsreel footage to bring events closer to home. A more concentrated effort was needed, and creative people were about to push the advertising community to the forefront of that effort.

A year prior to America's declaration of war, a gathering of artists, illustrators, cartoonists, printing industry leaders, and advertising executives met for dinner at the Hotel Astor in New York. Believing that war was imminent, the plan was to create "a store of war posters calling the nation to arm..." which would be distributed across the nation on over 90,000 billboards.

Within the year, a Federal Committee on Public Information had been formed, which included nineteen subdivisions, each with a specific focus, to promote pre-war support domestically while publicizing American war aims abroad. Among the subdivisions were the Division of News, the Division of Films, the Division of Syndicated Features, and the Division of Pictorial Publicity, which listed on its roster many names from the Astor Hotel dinner, including Howard Chandler Christy, J. C. Leyendecker, Norman Rockwell, and Charles Dana Gibson.

But of all the artists from the Astor dinner, magazine illustrator James Montgomery Flagg, a relative unknown at the time, would receive the most attention. His "I Want You" design attracted immediate approval and became a recruiting icon for generations to come. Flagg's concept was not entirely original, however. He had seen a British poster reproduced in *Punch* and created by illustrator Alfred Leete, showing Lord Kitchener, Britains' Secretary of State for War, looking directly at the viewer and pointing his finger over the bold heading: "Your Country Needs You."

Flagg "borrowed" the dramatic pose, and used a modified version of his own likeness for the face of Uncle Sam. For the upper portion of Uncle Sam's body (the British version showed only the head,

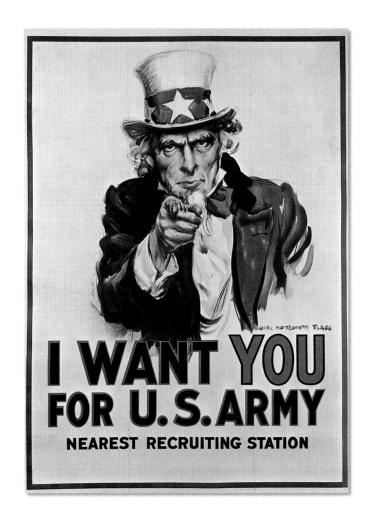

neck, outstretched arm, and hand of Lord Kitchener) Flagg hired Army veteran William Motts. The words "I Want You," appeared directly below the figure. As a new Uncle Sam was born and plastered across the United States, millions of men eagerly lined up to go to war. Millions more supported the war by buying war bonds.

Many factories switched to munitions production rather than consumer goods, creating severe shortages in a range of products, including rubber (needed to make tires for military vehicles), gasoline (to fuel them), fats (for glycerin used in explosives), and metal (for weapons, ammo, and other equipment). Although rationing was not enforced during World War I, a program of conservation was encouraged by the U.S. Food Administration, resulting in voluntary "Meatless Mondays" and "Wheatless Wednesdays" to help ensure the necessary food supplies for the troops.

Posters with powerful images and patriotic messages (many posted on space donated by the outdoor advertising industry), played an important role not only in promoting recruitment goals and sustaining public morale, but also by introducing programs that encouraged women to fill the jobs left by men gone to war, and to forge a unity between civilians and a military whose objectives were on foreign soil.

With the signing of the peace treaty at Versailles came hope of lasting world stability. For Germany, it brought the bitter seeds of defeat that would grow eventually to an even greater conflagration in the years to come. For America and her allies, it brought good times, fast living—and short memories.

☞ I Want You for U. S. Army, poster, 1917.

The definitive recruitment poster, it is perhaps the most recognizable American advertising icon of all time. Artist James Montgomery Flagg modeled Uncle Sam's face on his own.

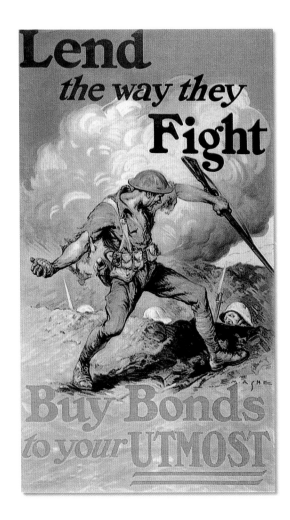

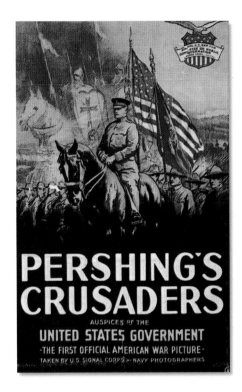

☞ **Pershing's Crusaders, poster, 1917.**

General Pershing, who led the American troops in Europe, is likened to the highly romantic image of a chivalric knight in shining armor.

Lend the Way They Fight, poster, 1918.

To help finance the war, the government launched numerous bond drives, and Americans responded by surpassing set goals. Twenty-five-cent stamps were also issued (a filled book of stamps bought a bond) along with the slogan, "Lick a stamp and lick the Kaiser."

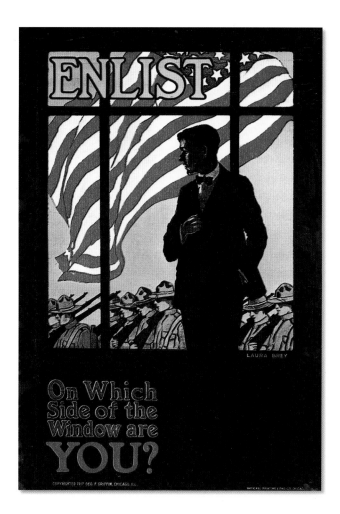

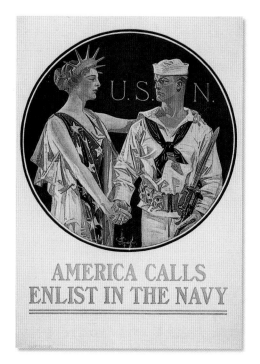

America Calls, poster, 1917.

Hand in hand, Lady Liberty and the U.S. Navy call for enlistment in a straightforward approach.

Enlist, poster, 1917.

Artist Laura Brey's recruiting poster differed from its counterparts which were, for the most part, direct patriotic pleas to join up. This image is more ambiguous. The figure in the darkened foreground has the stereotypical appearance of a dissident or intellectual which, in the iconography of the times, was synonymous with cowardice or subversive activities.

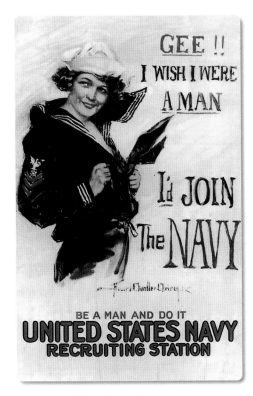

Gee!! I Wish I Were a Man, poster, 1917.

Howard Chandler Christy, whose illustrations of lovely young women were known as "Christy Girls," used unabashed sex appeal to recruit

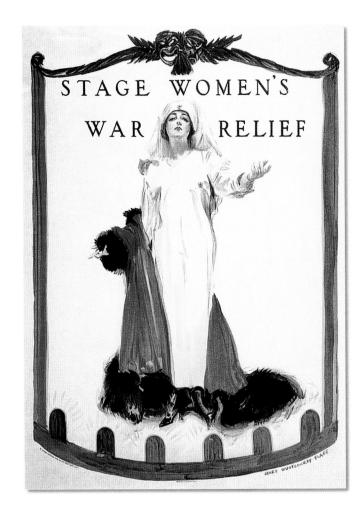

Stage Women's War Relief, poster, 1918.

Groups across America, many headed by the top celebrities of the day, held fundraisers to help the war effort. This elegant illustration by James Montgomery Flagg has an entirely different sensability from his famous recruiting poster on page 24, as it was intended for an entirely different audience (well-to-do socialites) for an entirely different purpose (parting with their money).

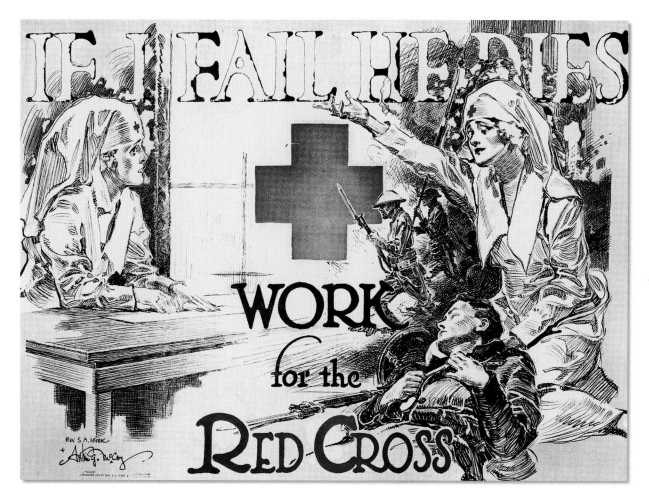

If I Fail He Dies, poster, 1918.

Hoping to touch the hearts of America, the Red Cross reached out for volunteers with this melo-dramatically illustrated design. However, it's no accident these dedicated young ladies resemble their Gibson Girl/Christy Girl counterparts.

1920–1929

A Stylish New Beginning

The mood in America following World War I was one of enormous optimism for the future. The nation had emerged relatively unscathed unlike its wartime friends and foes in Europe, who had suffered crushing losses both economically and in human lives.

Poised for an economic boom, the coming prosperity was attributable to the after effects of wartime technologies that had been developed to increase production at a time when labor was in short supply. More efficient production methods resulted in new goods and industries, which did not end with the conclusion of the war, but rather continued to evolve and grow. And with these advances came increasing worker productivity and higher wages, which in turn led to greater consumer buying power and the beginnings of the age of consumerism.

Of all the industries that benefited from America's new buying power, none was more far-reaching or had greater impact on the economy than the automotive industry. Its success prompted the growth of other industries, including steel, petroleum, and rubber. It also led to the creation of the national highway system as well as roadside service facilities. With the rise in sales of automobiles, from 8 million early in the decade to more than 23 million by 1929, motorists were happily discovering service stations, garages, cafes, and hotels, called motels, to cater to their needs along the highways—and, of course, mile after mile of billboards. America was on the move, for work and for recreation, and the automobile was fast becoming a practical necessity rather than an expensive luxury.

Advertisers soon learned that the budding car culture made it necessary to simplify their text-heavy signs. Messages had to register quickly with drivers through fewer words and simpler images. Short slogans and catchy phrases, boldly displayed, became the new trend: "Time to Retire" (Fisk Tires), "The Skin You Love to Touch" (Woodbury Facial Soap), "Good to the Last Drop" (Maxwell House Coffee). These tag lines became familiar and famous through repetition.

Billboards had taken on a new look, too. Boards in high-traffic districts and affluent neighborhoods were given freshly painted white

frames and a latticed base. Some had elaborately decorated frames, flanked by pilasters shaped in female forms, affectionately called "lizzies," and were illuminated by electric globes. A large clock or thermometer was another feature, and some were set back from the street or sidewalk on a grassy, landscaped plot.

Throughout the 1920s, advertising agencies congregated along New York's Madison Avenue. Mass production of goods meant more intense competition for consumers' dollars, thus the modern ad agencies had to become more specialized in their knowledge of their clients, their clients' competitors, and their clients' customers. As ad campaigns became more creative they also became more cohesive, which meant that a billboard series for a particular client would be the same in Chicago as in San Francisco. Talented art directors and creative copywriters were routinely relied upon to transform a struggling business into an "overnight" success. "The time has come when advertising in some hands has reached the status of science," commented Claude Hopkins, a brilliant copywriter for Lord and Thomas Agency.

Testimonials from men in trusted positions (bankers, doctors, scientists, statesmen, and religious leaders) grew increasingly popular, as well as celebrity endorsements from stage and screen stars. Makeup master Max Factor pioneered the use of celebrity promotion. His cosmetics were turning pretty actresses into America's new royalty beginning in the late 1920s. With women everywhere wanting to look like their favorite film actresses, Factor negotiated with the studios to promote these flawlessly made up faces while plugging their latest movies. Loretta Young, Jean Harlow, Clara Bow, and Bette Davis were the earliest stars to appear in Max Factor promotions.

But women had been promoting much more than lipstick and face powder. After years of perseverance by the Suffrage movement, the passage of the 19th Amendment in 1920 had given American women the right to vote in national elections.

American women rejected the Edwardian attitudes of early generations. They partied, smoked cigarettes, wore makeup, and danced to a new music form called jazz. They traded the lush beauty of the Gibson Girl for the sleek cheekiness of the flapper. They bobbed their hair, shortened their skirts, rolled down their stockings, and even bound their breasts for a boyish, flat-chested look.

The same year, the Volstead Act had become law, which banned the sale of alcohol. Thus, 1920 also ushered in Prohibition, a decade-plus of bathtub gin, bootleggers, racketeering, and speakeasies, and an era that would come to be known as the Roaring Twenties.

By September 1929, the New York Stock Exchange was more active than it had ever been. No doubt about it—the rich were getting richer. But on October 29th, forever remembered as Black Tuesday, the bottom fell out of the market and nearly $15 billion had suddenly vanished. Entire fortunes were wiped out, banks closed, and credit became a thing of the past. The Great Depression had begun.

Wallscape and billboards, 1920.

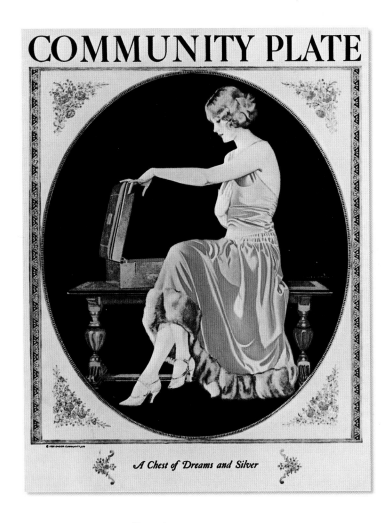

COMMUNITY PLATE

A Chest of Dreams and Silver

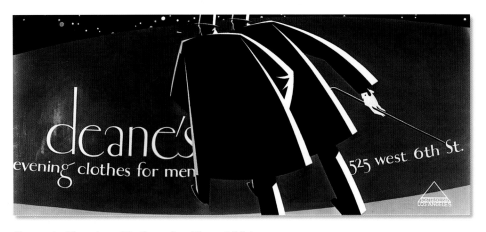

Deane's Evening Clothes for Men, 1924.

Highly stylized Art Deco severity is in striking contrast to the romantic Christy Girl image opposite.

☞ **Community Plate, poster, 1924.**

Another illustration by Howard Chandler Christy, this Christy Girl is less exuberant than the example on page 28. The product, silver plated cutlery, is unseen, but you know it's beautiful by the model's silent-screen-star-like reaction.

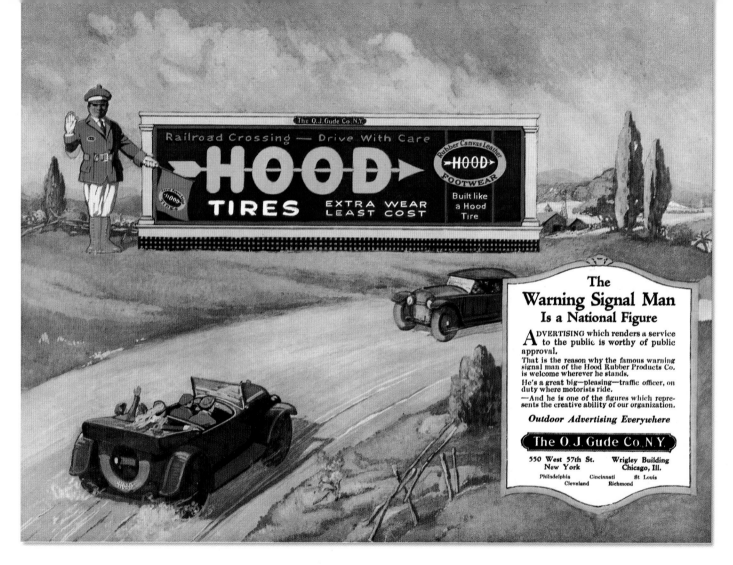

Hood Tires, 1924.

Unusual billboard depicts a sign within a sign. A large percentage of boards from the early 1920s were aimed at drivers, promoting parts and other products for their not-always-reliable cars.

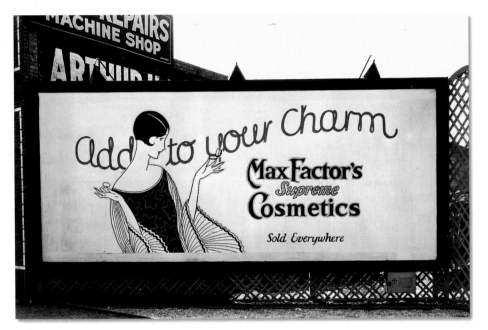

Max Factor's Supreme Cosmetics, 1925.

Until Max Factor arrived in Hollywood, "nice" middle and working class women did not wear makeup. But Factor changed the image, and the business, of cosmetics thanks to exceptional promotional saavy. By creating makeup for the cinema, he redefined the standards of modern beauty. Once women saw their favorite film stars looking flawlessly beautiful in Max Factor makeup, they wanted the same for themselves.

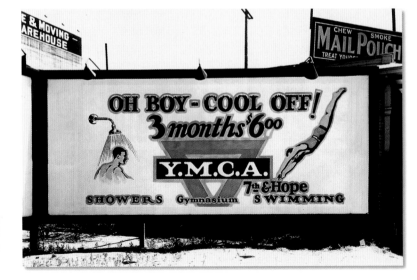

Oh Boy—Cool Off, 1925.

Swimming pools began to appear in YMCAs during the 1880s thanks to a nationwide expansion program.

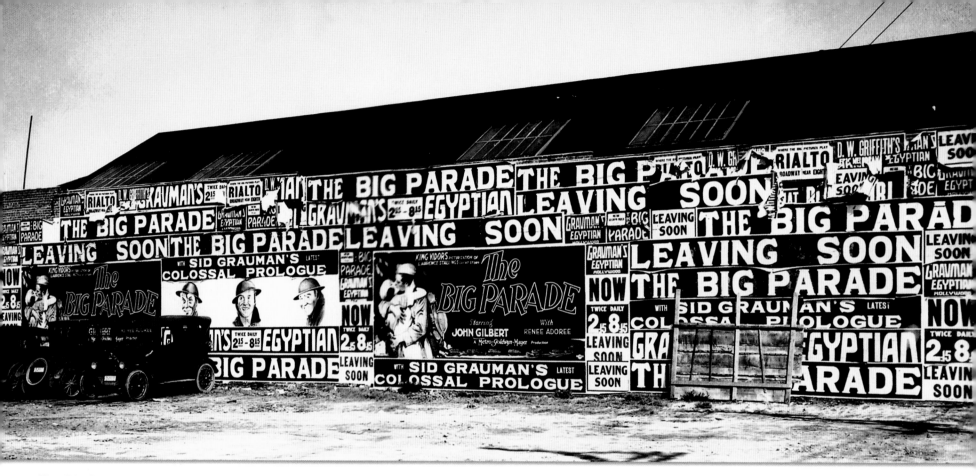

The Big Parade, 1925.

What appears to be a jumbled assortment of billboard papers is actually the careful placement of dozens of posters promoting a single subject, a thrilling World War I epic released by MGM. The unusual posting covered the length of an entire warehouse wall.

Double row of lizzie boards, 1926.

The distinctive female busts flanking each sign, are also illuminated along San Francisco's busy Market Street.

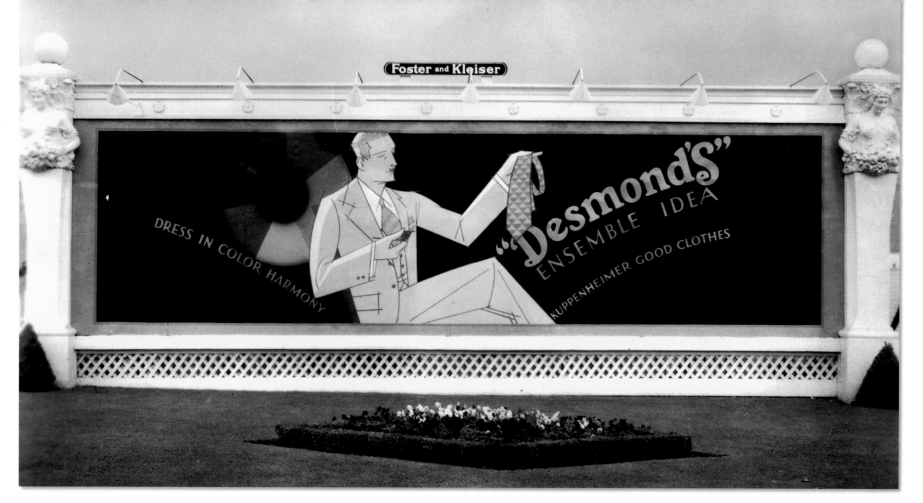

Desmond's, 1927.

Handsome example of a deluxe landscaped lizzie board.

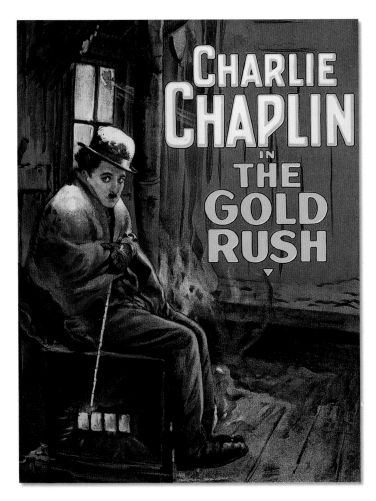

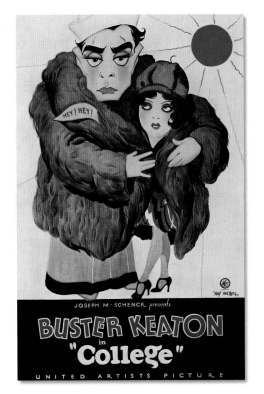

College, poster, 1927.

Silent comedian Buster Keaton was nicknamed "Buster" as a youngster by magician Harry Houdini. The illustration by Hap Hadley is an edgy caricature intended to convey sophisticated humor rather than sentimental comedy.

☞ *The Gold Rush,* poster, 1925.

Charlie Chaplin's immortal character of the Little Tramp found himself pitted against the perils of the Yukon in this silent masterpiece. The soft edges and naturalistic illustration style contribute to the sentimentality of the image.

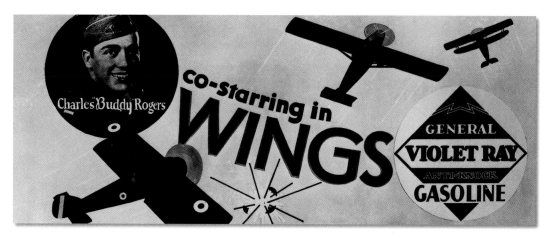

✒ *Wings* and General Violet Ray Gasoline, 1927.

Soaring planes in combat dominate the promotional billboard for the silent feature that became the first Academy Award-winner for best film. The Violet Ray logo made for a rare early movie/product tie-in.

Air Mail–Now One Day to the ☞ East, 1927.

The first airmail route in the United States, which went from New York to Washington, DC with a stop in Philadelphia, a distance of approximately 218 miles, began on May 15, 1918.

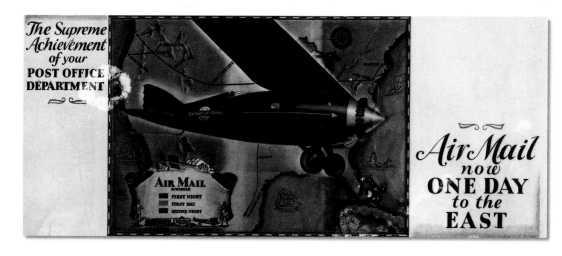

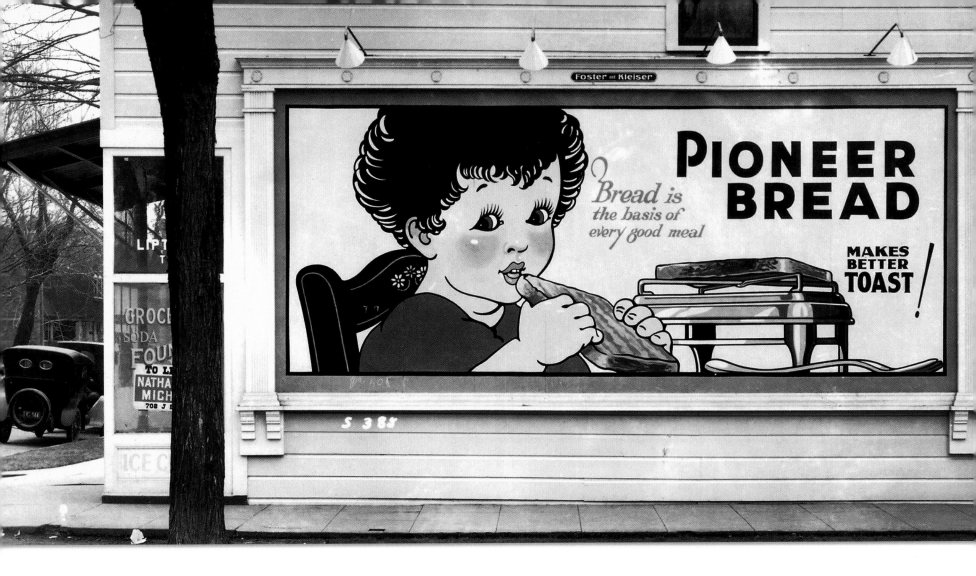

Looking west down Prindeville from Milwaukee Avenue,
Chicago, 1928.

☞ Pioneer Bread, 1927.

Although children had no buying power of their own in the 1920s, ad execs discov-
ered that infants and toddlers were extremely effective ad icons, a view shared by
today's marketing pros.

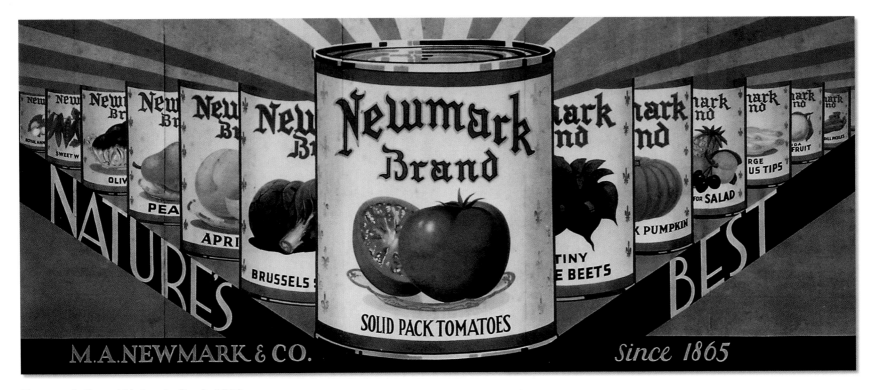

Newmark Brand Nature's Best, 1928.

A more formally framed board on Melrose Avenue, Los Angeles.

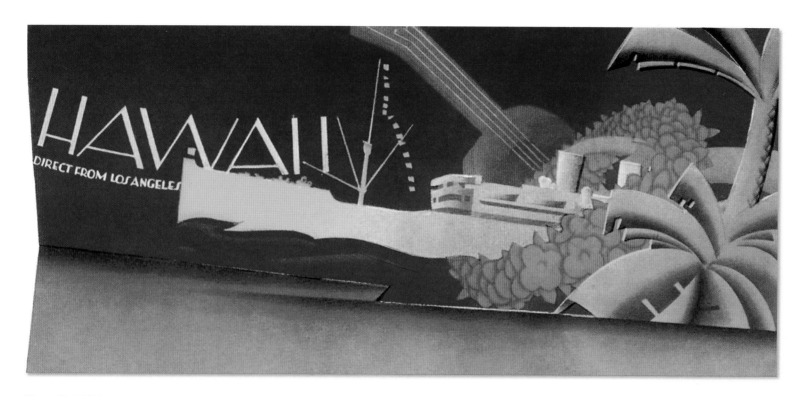

Hawaii, 1928.

A vibrant example of a highly stylized architectural Art Deco design. "Arnold Armatage was the only left-handed artist I've ever met," remembered Foster and Kleiser's archivist, Joe Blackstock. "He was an incredibly fast worker, painting large designs with either a brush or pallet knife. With a radio playing nearby, he could converse with visitors while he painted. Nothing seemed to distract him."

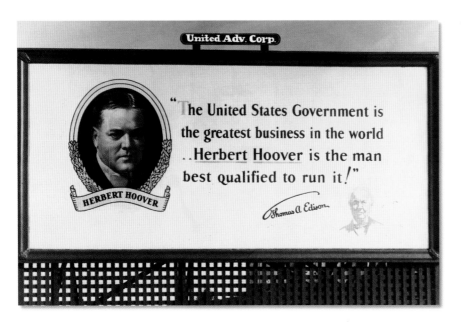

☜ **Herbert Hoover, 1928.**

Hoover won the election, no doubt helped along by celebrity endorsements like this one from Thomas Edison. But his promise of prosperity for the nation was lost with the stock market crash of 1929 and the Great Depression that followed. He served only one term.

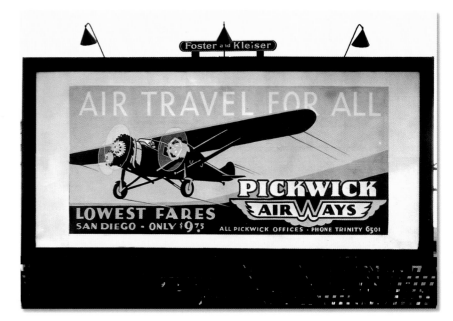

Air Travel for All – Pickwick Airways, 1929.

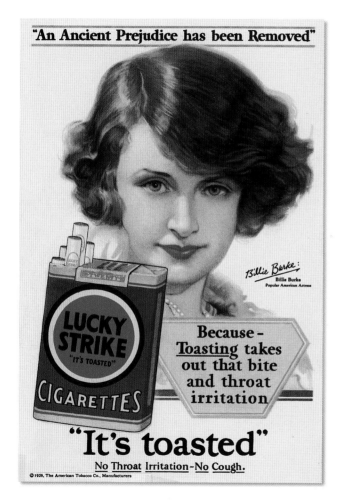

"An Ancient Prejudice has been Removed"

Billie Burke
Billie Burke
Popular American Actress

LUCKY STRIKE
"IT'S TOASTED"
CIGARETTES

Because - Toasting takes out that bite and throat irritation

"It's toasted"

No Throat Irritation-No Cough.

© 1929, The American Tobacco Co., Manufacturers

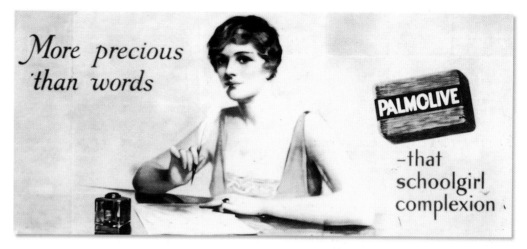

More precious than words

PALMOLIVE

-that schoolgirl complexion

Palmolive, 1927.

In 1898 the Johnson Soap Company introduced a soap made from palm and olive oils and called it Palmolive. The dubious idea that a youthful appearance was more desirable than writing skill would be perfectly at home on a billboard today.

☞ Lucky Strike, poster, 1929.

Actress Billie Burke, wife of legendary Broadway producer Florenz Ziegfield, championed the advantages of smoking Lucky Strike cigarettes. In a classic celebrity endorsement, tobacco companies were targeting women by appealing to their growing sense of independence and sophistication.

1930—1939

Uplifting Depression Spirits

Following a decade of prosperity, the stock market crash of 1929 left millions of Americans out of work and out of money. Advertisers tried to counter the grim reality by offering tremendous values and positive messages, often showing film stars or society figures in luxurious settings. Reminding the consumer of hard times wouldn't sell products, so advertisers stressed prosperity and the American dream by urging the public to "Be American—Buy American."

Newly elected in 1932, President Franklin D. Roosevelt's New Deal introduced fifteen major bills that were passed during his first 100 days in office. This widely inclusive legislation package was designed to provide jobs through multibillion dollar federal construction projects, as well as refinancing for home and farm mortgages, guaranteeing bank deposits, and more. The National Recovery Administration (NRA), a two-year plan to send Americans back to work, had flag-waving supporters parading through city streets as over two million employers signed on to display the NRA emblem.

Sampling by mail became a strong marketing tool. General Foods, Wrigley, Gillette, Vicks, and other big corporations distributed millions of free samples to eager recipients. Sears and Roebuck, the world's largest mail-order house and largest retailer, announced sales of over $443 million in 1930, estimated to be one percent of America's retail trade. Sears' sales secret: better design for inexpensive merchandise. "Because a thing is cheap," said Dr. A. S. Snow, merchandise analysis director of Sears, "it does not follow that it should be ugly."

The news from overseas was far less encouraging. Adolph Hitler had become Chancellor of Germany, and in Rome, before a cheering crowd, Italian dictator Benito Mussolini said, "We must become a warlike nation." But few Americans paid much attention to these ominous developments. Instead, over 38 million people were drawn to the Chicago World's Fair where spectacular exhibitions heralded "A Century of Progress."

Late in 1932, great black clouds began to sweep east from the Great Plains, choking the air with dust particles, reaching as far as Chicago, then New England, and finally Washington, DC, before moving out to sea. The worst drought in history had turned overworked soil to dust, forcing thousands of poor farm families to pile their scant belongings into rickety vehicles and head west to escape the Dust Bowl in search of fertile land in California's verdant valleys.

Hollywood studio heads knew the public was hungry for distraction from the reality of the times, if only for a few hours. The answer came in the form of musicals starring Fred Astaire and Ginger Rogers, Nelson Eddy and Jeanette MacDonald, Dick Powell and Ruby Keeler, Alice Faye, Shirley Temple, Judy Garland, Deanna Durbin, Bing Crosby, and the Marx Brothers. Elegant sets and stunning costumes supported story lines that had the lead characters rising from poverty to prosperity. The music was upbeat and songs were filled with hope: "Happy Days Are Here Again" written in 1929, became an anthem during the Depression, along with feel-good melodies like "Pick Yourself Up," "We're In the Money," "With Plenty of Money and You," "I Found a Million Dollar Baby (in a Five and Ten Cent Store)," and "Wrap Your Troubles in Dreams."

Meanwhile, radio (the Philco table model sold for $18.75) offered hours of laughter courtesy of George Burns and Gracie Allen, Fibber McGee and Molly, Jack Benny, Fred Allen, Lum and Abner,

Amos n' Andy, Edgar Bergen and Charlie McCarthy. Listeners could also enjoy the big band music of Kay Kyser, Glenn Miller, Benny Goodman, Duke Ellington, and Guy Lombardo.

Buying on the installment plan became hugely popular, allowing consumers to purchase items they otherwise wouldn't have been able to afford. By 1938, there were 13 million unemployed Americans, versus 25 million at the start of the decade. In Europe, Hitler had taken command of the German army and signed a nonaggression pact with Russia, only to invade Poland with three million German and Russian troops. Despite these developments, "America does not want war," stated an editorial in a leading business publication, "nor yearn for war profits. But if war should come, it is entirely probable that after the first few months of disturbance and adjustment, our business level would rise sharply. Advertising, which always responds to the general business curve, would go up with it. Consequently, those interested in business and advertising may assume that if disaster strikes, the economy would be on its way to recovery."

As Poland was being invaded, America was celebrating the openings of two world's fairs, one on each coast. The New York World's Fair promoted futuristic dreams of tomorrow, while in San Francisco the event officially known as the Golden Gate International Exposition was dedicated to world peace and brotherhood.

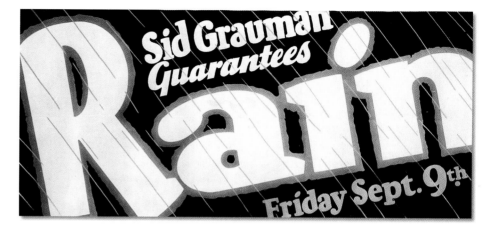

Rain, 1932.

Hollywood premier of the early talkie version of a W. Somerset Maugham story.

☞ **Arrow Shirts, poster, 1930.**

Not unlike the luxury cars of the same name, elegance and style were keys to the Arrow promotions, portrayed by the handsome, clean-cut young men created for the Arrow Collar Company by illustrator J. C. Leyendecker. So successful was the campaign, and Leyendecker's creation, that many young women believed he was real, prompting fan mail and even marriage proposals.

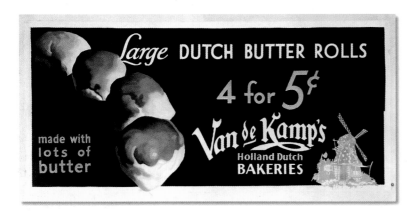

The Holland Dutch bakeries and restaurants were easily spotted throughout Southern California by the company's trademark windmill logo, included on this billboard specifically for image branding purposes.

Cream of Wheat, 1932.

Like Aunt Jemima and Uncle Ben, an illustration image of a black chef was featured on boxes of Cream of Wheat, with the idea that this image would impart a sense of high quality, sound nutrition, and good eating.

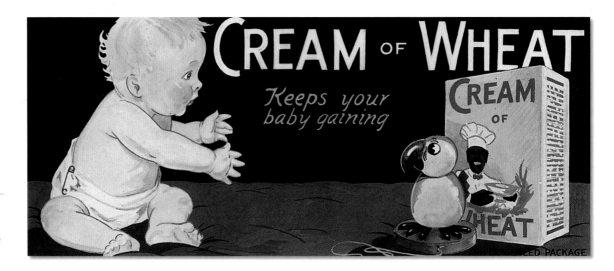

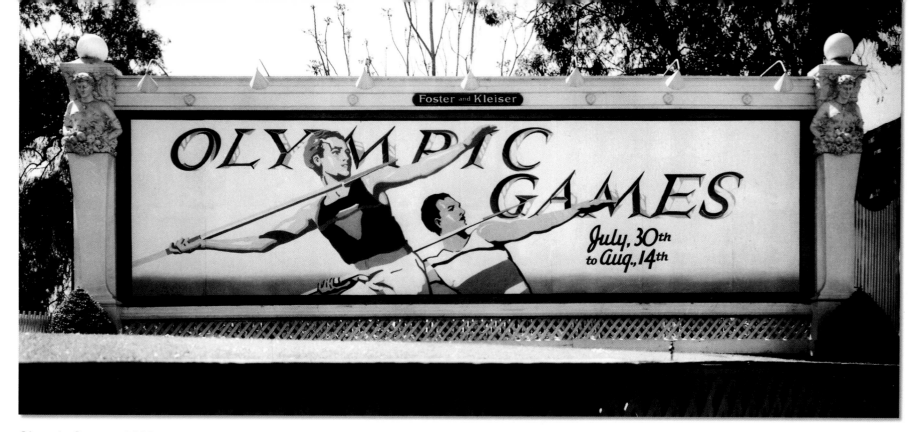

Olympic Games, 1932.

Only months before the opening of the Olympics in Los Angeles, there seemed to be little public interest, despite stylish billboards like this one. Hit hard by the Depression, few nations could afford to send their athletes all the way to California, and ticket sales to the events were dismal. It wasn't until Hollywood stars like Charlie Chaplin, Marlene Dietrich, and Mary Pickford offered to entertain visiting dignitaries and other guests that interest finally picked up.

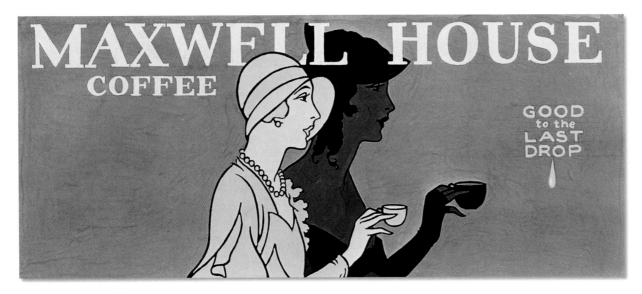

Maxwell House Coffee, 1932.

The slogan, "Good to the last drop," is one of the most successful and memorable of all time.

RCA Victor Auto Radio, 1933. 👉

In 1920, commercial radio made its broadcast debut with the call letters KDKA in Pittsburgh, Pennsylvania. By 1923, nearly 600 stations were broadcasting and Americans were snapping up radio sets and tuning in to the newscasts, weather reports, election returns, radio plays, musical concerts, and radio personalities who were introduced over the airwaves and enjoyed extraordinary popularity. By the early 1930s radio sets were being installed in luxury automobiles. The RCA mascot Nipper the dog, one of the most beloved in history, along with the slogan famous "His Master's Voice," was introduced in 1904 for the Victor Talking Machine, better known as the Victrola.

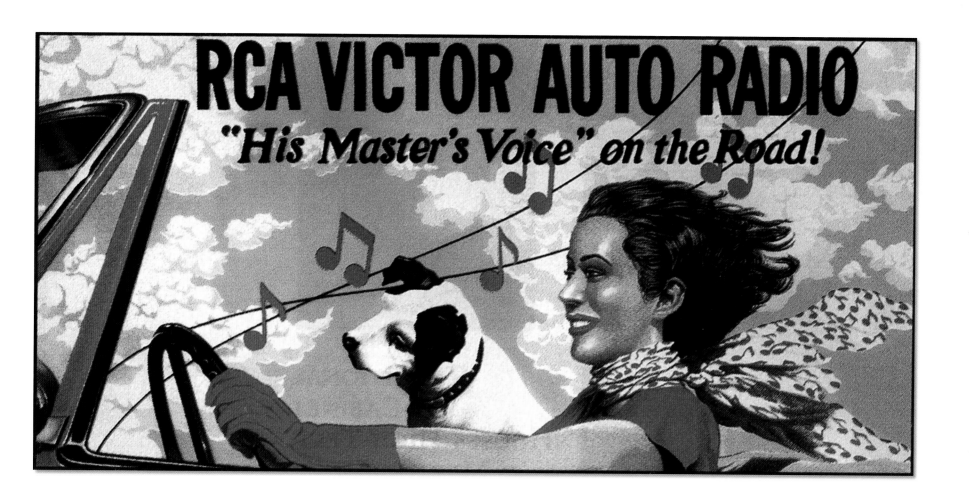

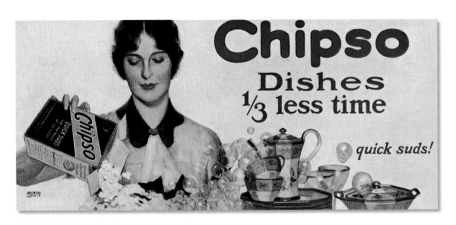

☞ Chipso, 1933.

When washing machines replaced the tedious job of scrubbing laundry by hand, Proctor & Gamble developed the first detergent specifically made for the new washers. Before Chipso, it was necessary to grate a bar of soap to make soap chips. The new brand offered homemakers a ready-to-use soap product in a handy box.

For You and Yours, 1933.

Although there's no actual bread in sight, Dorsey's Kew-Bee Bread knew this cozy family scene would send a message of wholesome goodness.

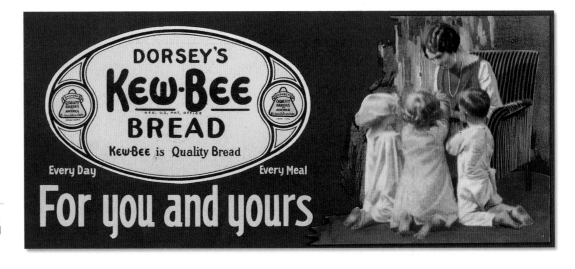

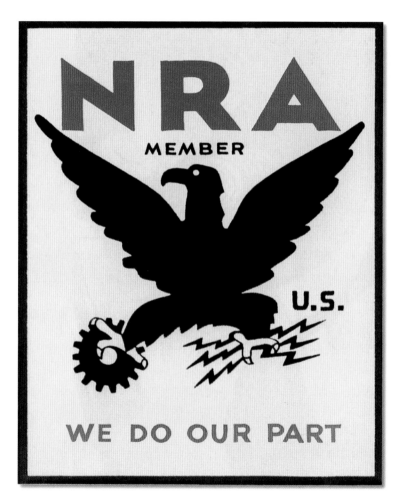

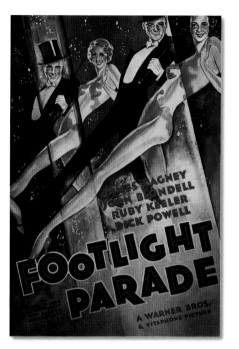

🖰 *Footlight Parade,* poster, 1933.

One of a series of successful Warner Brothers' musicals directed by the innovative Busby Berkeley. "In an era of breadlines, depression and wars," Berkeley reflected, years later, "I tried to help people get away from all the misery… to turn their minds to something else. I wanted to make them happy, if only for an hour." Skimpy costumes, emphasized in this poster, certainly didn't hurt the cause.

NRA, poster, 1933.

The National Recovery Agency (NRA) was a federal program created to regulate wages, working hours and, indirectly, prices during the Depression. The blue eagle emblem could be seen everywhere, and advertisers used it as show of support for the new NRA codes. The most revolutionary, and controversial, aspect of President Roosevelt's New Deal plan (opponents claimed the initials stood for "No Recovery Allowed") the NRA was eventually declared unconstitutional by the Supreme Court in 1935.

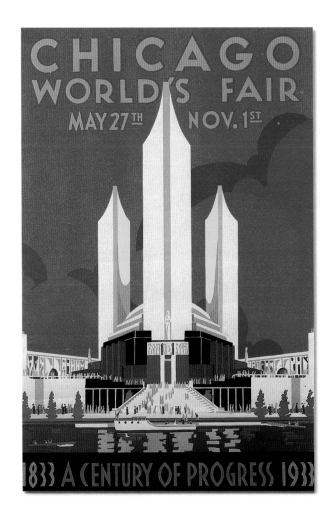

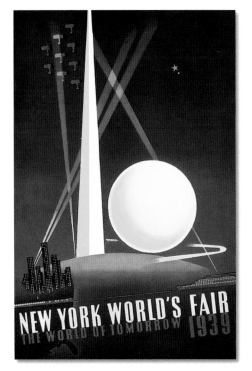

👉 New York World's Fair, poster, 1939.

One of the largest world's fairs of all time, it attracted more than 45 million visitors over 18 months, from April 30, 1939 to October 17, 1940. Its "World of Tomorrow" theme promoted optimism and prosperity in a time of depression and international unrest. The futuristic Trylon and Perisphere, a 700-foot spire and a sphere as wide as a city block, were its emblelms. Poster design and artwork by Nembhard N. Culin.

Chicago World's Fair, poster, 1933.

A sense of excitement is conveyed by brilliant color and vertical Art Deco stylization. Architectural elements also appear in the New York World's Fair poster (above), although by the end of the decade, the palette was much darker, a harbinger of what the future held in store.

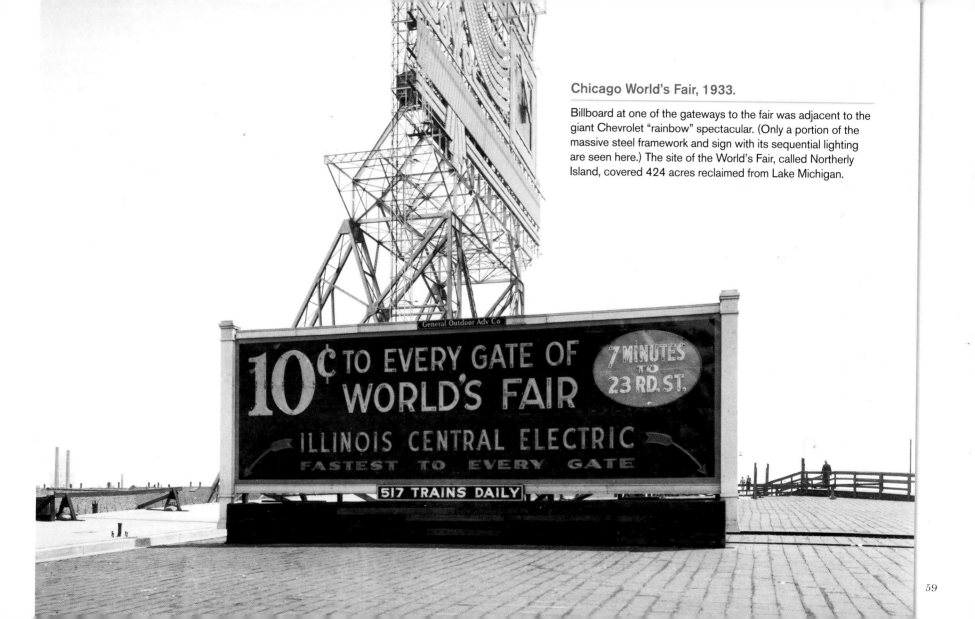

Chicago World's Fair, 1933.

Billboard at one of the gateways to the fair was adjacent to the giant Chevrolet "rainbow" spectacular. (Only a portion of the massive steel framework and sign with its sequential lighting are seen here.) The site of the World's Fair, called Northerly Island, covered 424 acres reclaimed from Lake Michigan.

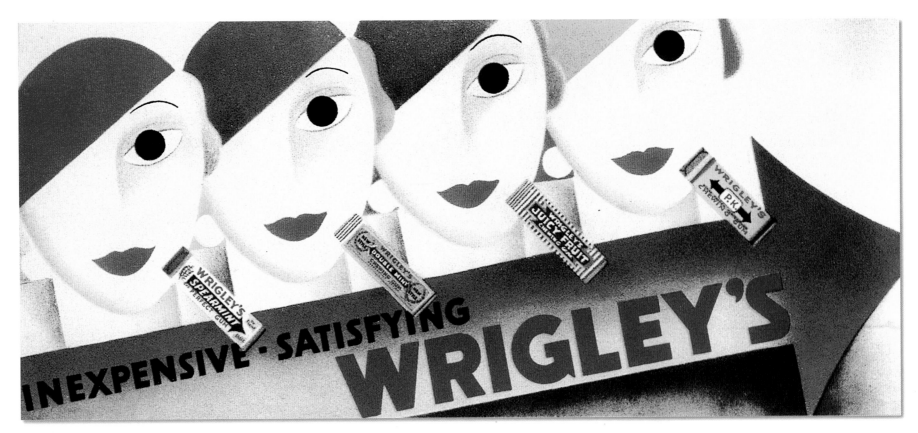

Inexpensive Satisfying Wrigley's, 1934.

This sophisticated, somewhat abstract graphic is a total departure from the straight-forward Wrigley's billboard on page 20.

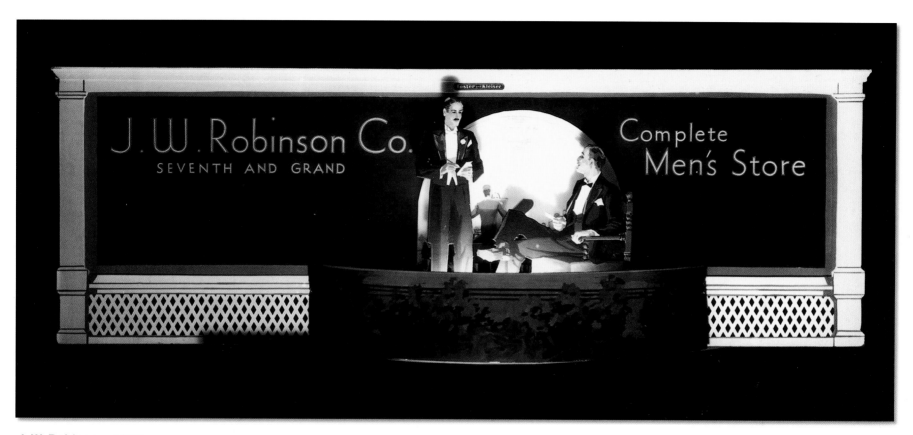

J. W. Robinson, 1934.

Soft sell during hard times. Early three-dimensional board became even more dramatic and lifelike after dark.

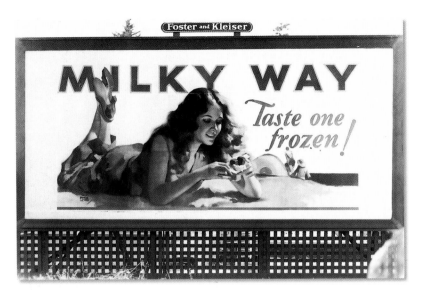

Milky Way, 1935.

Created in 1923 by candy king Frank Mars, whose earlier product, the Mars Bar, bears his name. Lighter in texture than its predecessor, Milky Way was once advertised as "the chocolate bar you can eat between meals without ruining your appetite." But by the mid-1930s, the image of a pretty girl was all that was needed.

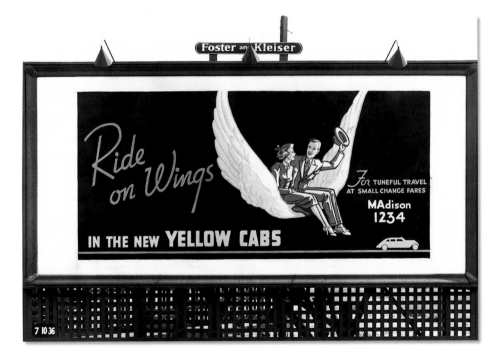

Ride on Wings, 1935.

The slogan "For tuneful travel for small change fares" suggests that Yellow cabs were equipped with radios, by no means a standard feature for cars of the period.

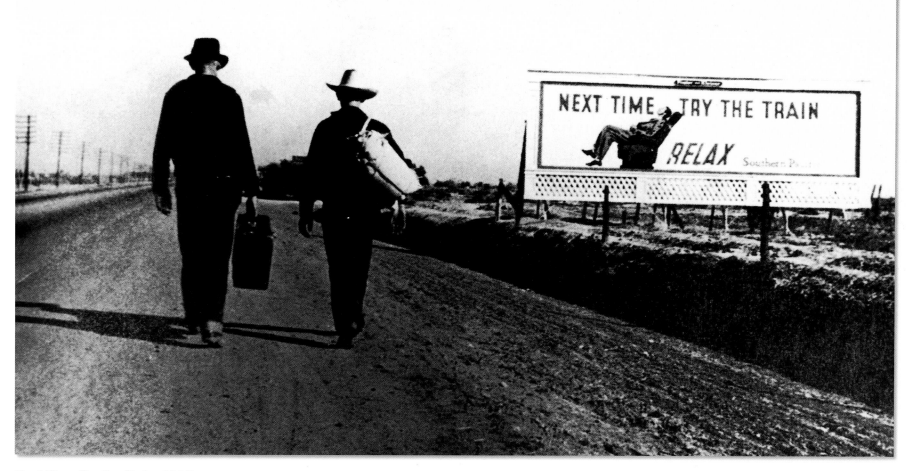

Next Time Try the Train, 1935.

Jobless California migrant workers walk along a dirt road as they pass a Southern Pacific
billboard in this award-winning photo by Dorothea Lange.

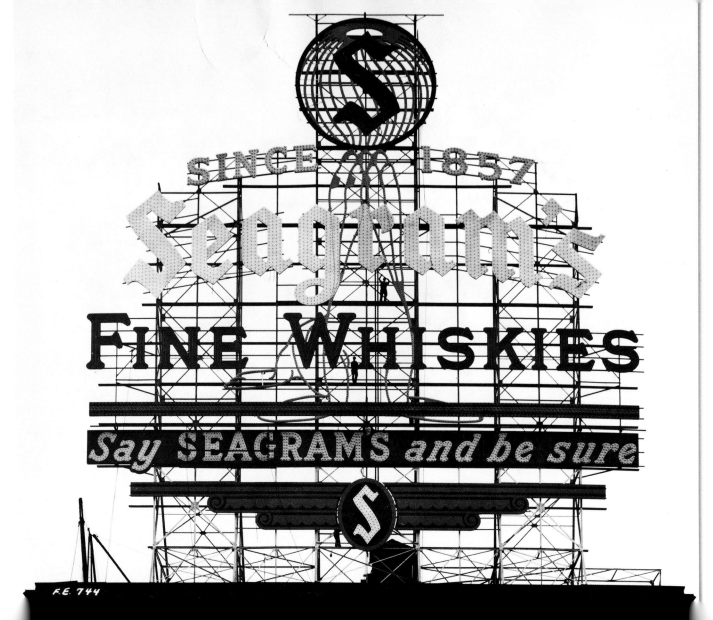

Seagram's Fine Whiskies, 1935.

Rising high above Michigan Avenue at Wacker Drive in Chicago, the massive grid work of the colorful lighted display dwarfs two workmen, standing center (under the "r" in Seagram's and between the "W" and "H" in Whiskies).

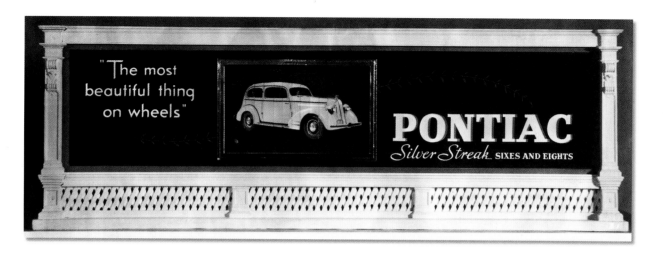

Pontiac, 1935.

Elongated "lizzie" with a central message board that rotated on vertical louvers, changing from the Pontiac logo to an illustration of the latest Silver Streak model. Edward Murphy founded the Pontiac Buggy Company in Pontiac, Michigan in 1893, but he switched at the turn of the century to making, as he put it, "those noisy, smelly, unreliable automobiles."

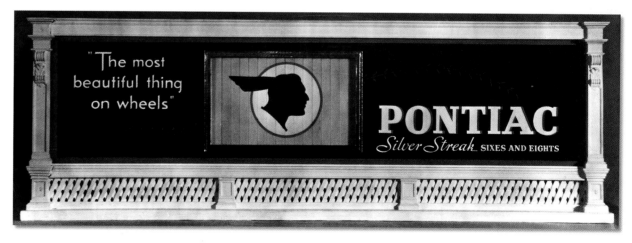

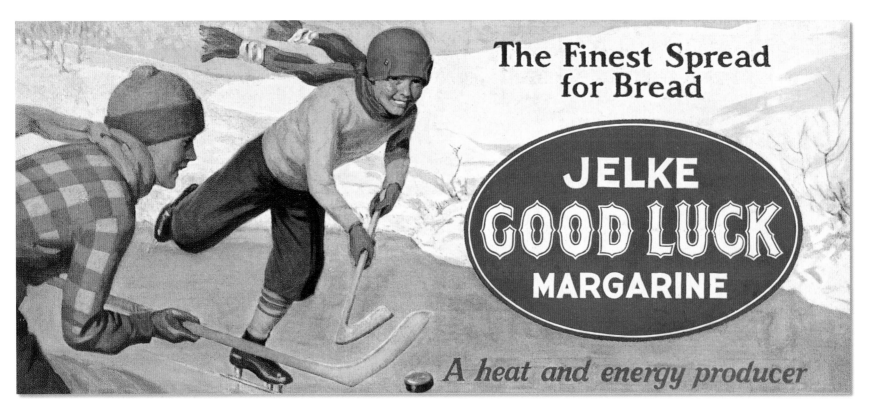

Jelke Good Luck Margarine, 1935.

Margarine was one of the many products developed to address rationing issues, however, its consumption remained low compared to butter until it again became a matter of patriotism to reserve "the real thing" for the troops.

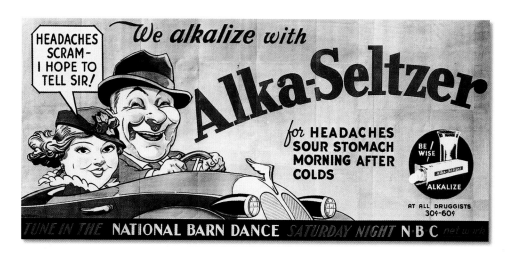

The familiar "Speedy" character was not introduced until 1951.

Vote for Landon, 1936.

Alfred "Alf" Landon was a leader in the petroleum industry when he enlisted in the Army at the start of World War I. Active in the Republican party, he served two terms as governor of Kansas and, in 1936, received the Republican nomination for president, a campaign he lost to incumbent Franklin D. Roosevelt. He nevertheless became known as "The Grand Old Man of the Grand Old Party." Landon died in 1987 at the age of 100.

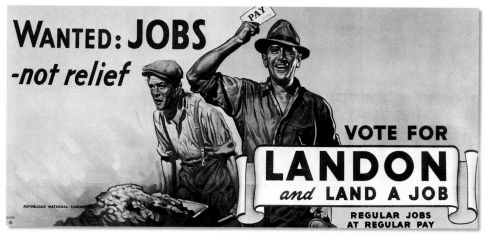

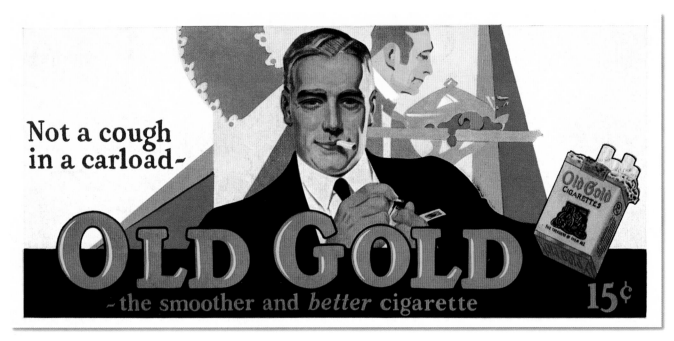

Not a cough in a carload~

OLD GOLD

~the smoother and *better* cigarette

15¢

Old Gold, 1937.

Smokers have always been portrayed as confident individuals in advertising, and this example is no exception. However, it is interesting that this ad acknowledges that some cigarettes have unpleasant side effects, such as coughing.

Calvert Whiskies, 1938. ☞

Striking, multi-functional Calvert ad on Wilshire Boulevard in Los Angeles featured above-the-board lettering lit with neon tubing (introduced in 1927) as well as an illuminated clock.

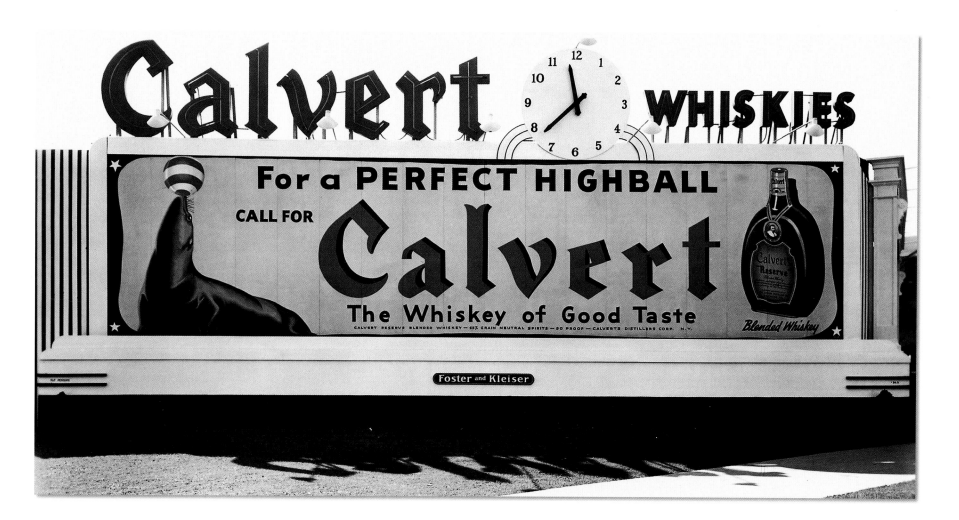

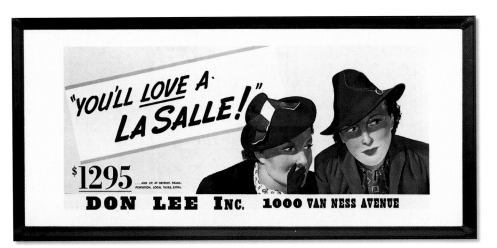

👉 You'll Love a La Salle, 1938.

In contrast to the Chevrolet ad from the same year, the reasonable price tag was featured in this campaign. The La Salle was designed by Earl Harley and introduced in 1927. Harley later designed the sporty Corvette in 1953.

You'll Be Ahead with a Chevrolet, 1938.

As the Great Depression dragged on, Americans were urged to buy automobiles as a way to spur the sagging economy. "How is this possible," critics responded, "when we are going without food?" Although the illustration style is far more naturalistically rendered, these models are also dressed for a night on the town, recalling the aristocrats portrayed in the early Pierce Arrow poster on page 16.

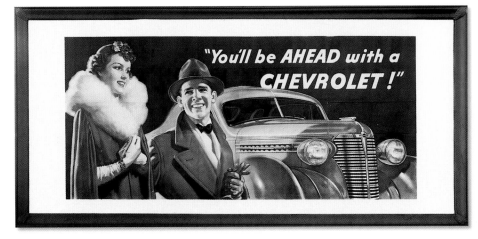

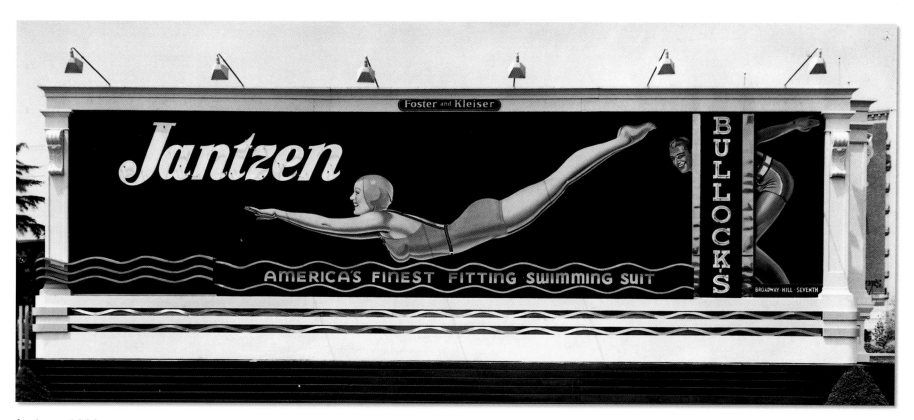

Jantzen, 1939.

The Petty Girl, created for *Esquire* magazine by airbrush artist George Petty, was the same leggy model used for Jantzen swimsuits, which boasted it had "changed bathing to swimming." The swan dive pose provided the perfect composition for the horizontal billboard.

1940—1941

Uncertain Times

While the conflict in Europe erupted into all-out war, the U.S. had declared its so-called neutrality in 1939. The mood of the country was mixed. As the decade began, the effects of the Great Depression were still being felt: Millions of Americans remained unemployed; bread lines and soup kitchens continued to be an everyday reality for many citizens; with the median annual income hovering below $1,000, teenagers were dropping out of high school to help support their families; and President Roosevelt's domestic policies were being questioned, particularly his New Deal.

Like the United States, Germany and Japan had suffered severely during the Depression. Japan, in particular, continued to rely heavily on imported goods and desperately needed land for its burgeoning population. Japanese military leaders saw China as the solution and, in the early 1930s, occupied extensive areas of Manchuria, which in turn led to full-scale war between the two nations. In 1940, Japan signed a formal alliance with Germany and Italy, angering President Roosevelt, who froze Japanese assets and placed an embargo on oil and steel shipments. No longer able to import resources essential to its war effort, Japan plotted to retaliate.

By late 1940, Britain was under siege as German bombers staged unrelenting blitzkrieg attacks. Although still determined to maintain its neutrality, Congress ratified the Lend-Lease Act to save the British from total collapse. (During the next six years the U.S. would give $50 billion in aid to the British and 37 other nations.) This was followed in mid-1941 by a secret meeting aboard a U.S. Navy cruiser off Newfoundland between President Roosevelt and Prime Minister Winston Churchill. Together they formulated the Atlantic Charter, an expression of their countries' aims in a war the U.S. had yet to officially join.

As America's relations with Japan became more strained, diplomats from both counties met in Washington, D.C. to defuse the crisis in early December 1941. However, a fleet of six Japanese aircraft carriers and fourteen escort vessels had already gathered in the Pacific, and on December 7 launched an attack over Honolulu, in the territory of Hawaii.

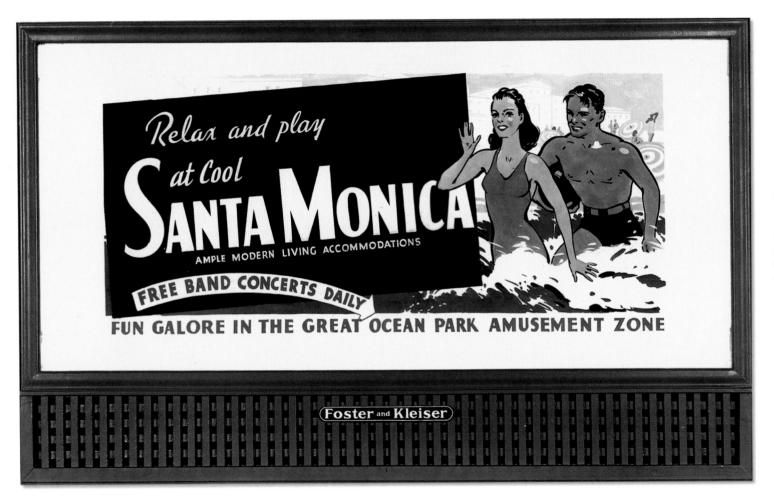

Relax and Play at Cool Santa Monica, 1940.

After more than decade of lean times, pleasure-starved Americans were eager for diversion.

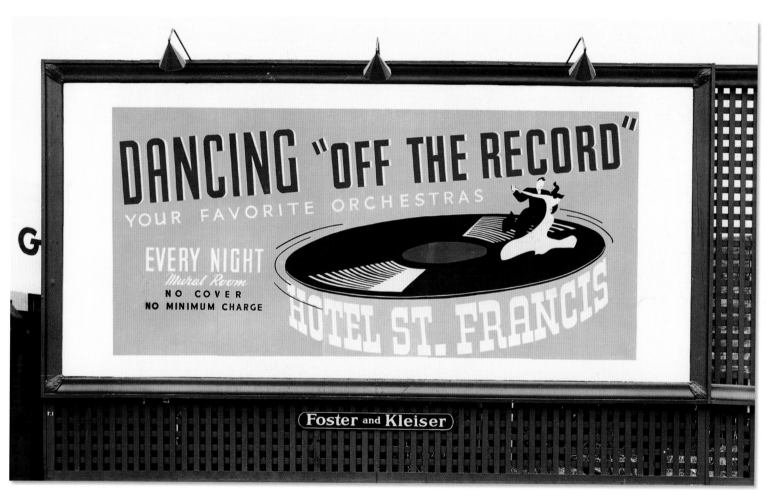

Dancing Off the Record, 1940.

San Francisco's famed Hotel St. Francis featured many of the top dance bands nightly in the Mural Room prior to World War II. The hotel celebrated its centennial in 2004.

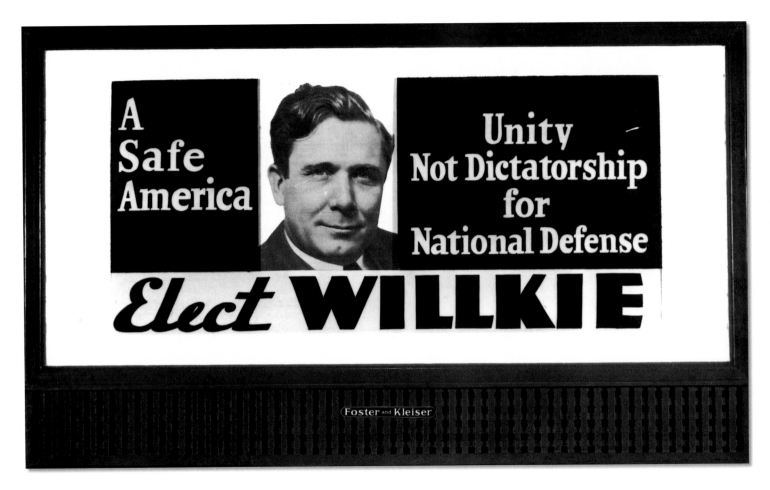

A Safe America

Unity Not Dictatorship for National Defense

Elect **WILLKIE**

Foster and Kleiser

Elect Wilke, 1940.

Originally a Democrat, Wendell Wilke switched parties in 1939 opposing Franklin D. Roosevelt's New Deal and capitalizing on the administration's lack of military preparedness. Wilke's chances against the incumbent president were hurt when Roosevelt expanded military contracts and instituted the draft.

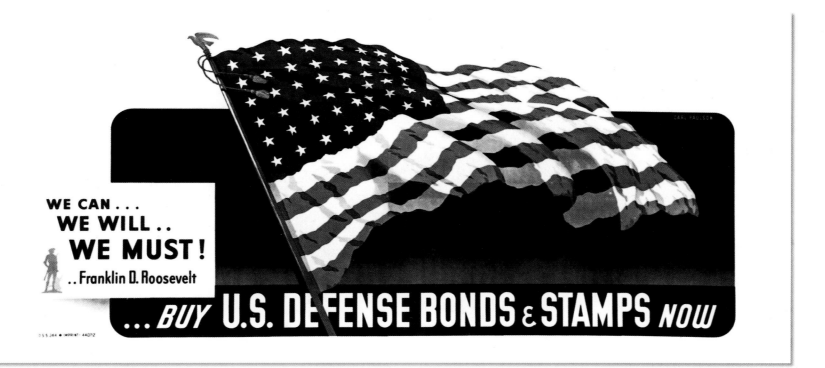

Buy U.S. Defense Bonds & Stamps Now, 1940.

With war escalating in Europe, patriotism became the theme for investing in America's defense. Created by Carl Paulson for the U.S. Treasury Department, this was the most popular billboard design throughout the war years. Displayed at more than 30,000 locations in 18,000 cities and towns across the country, 4 million small color prints were reproduced to fulfill public requests for the striking image.

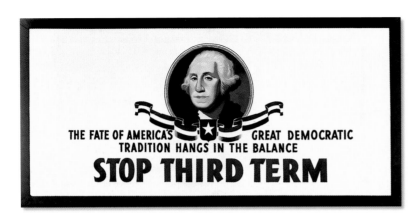

First elected in 1932, President Franklin D. Roosevelt served two terms, and ran again in 1940 for a third. Many Americans, including members of his own Democratic party, opposed FDR's reelection largely because of his shift from previously stated neutrality to open support of Britain amid the horrific war news coming from Europe.

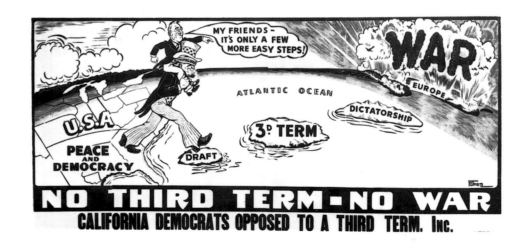

No Third Term – No War, 1940.

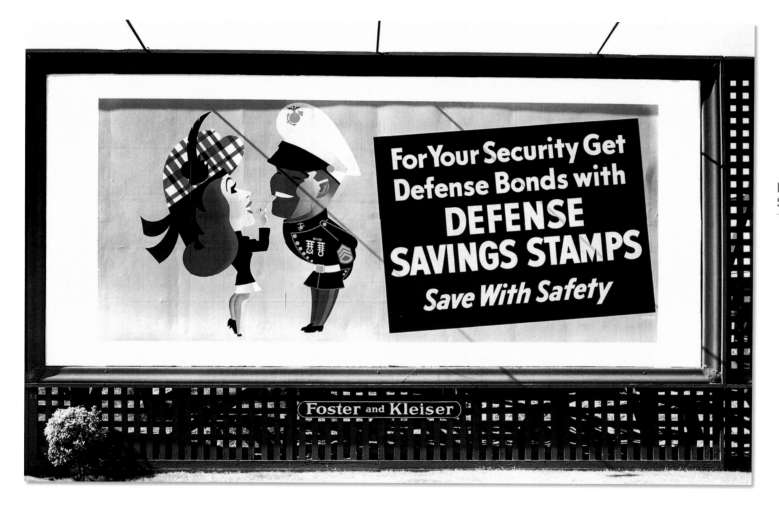

For Your Security Get
Defense Bonds with
**DEFENSE
SAVINGS STAMPS**
Save With Safety

Foster and Kleiser

Defense Savings
Stamps, 1940.

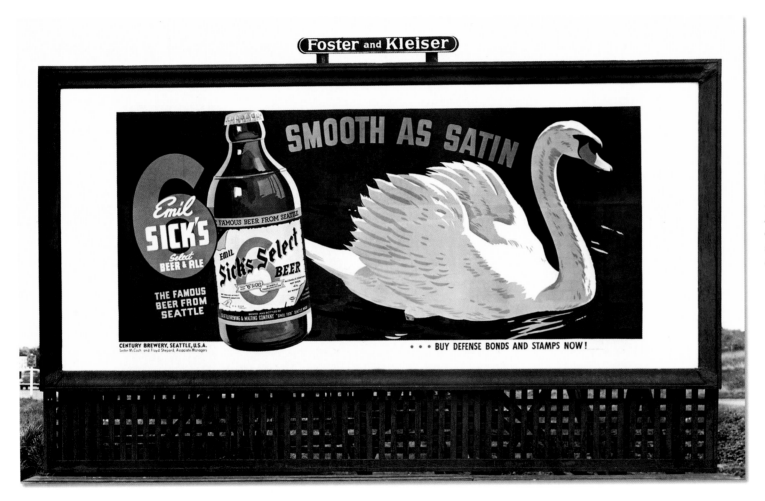

Emil Sick's Select Beer, 1940.

A subtle plea to buy defense bonds and stamps. Most billboards carried this reminder…

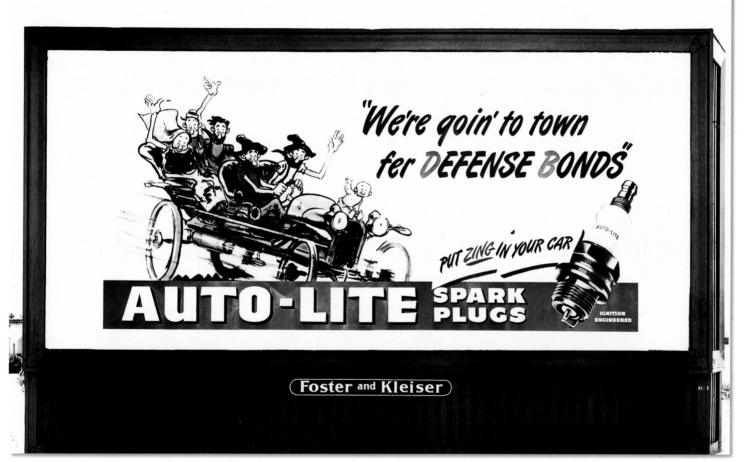

Auto-Lite Spark
Plugs, 1940.

…which grew bigger
and bolder as the year
wore on.

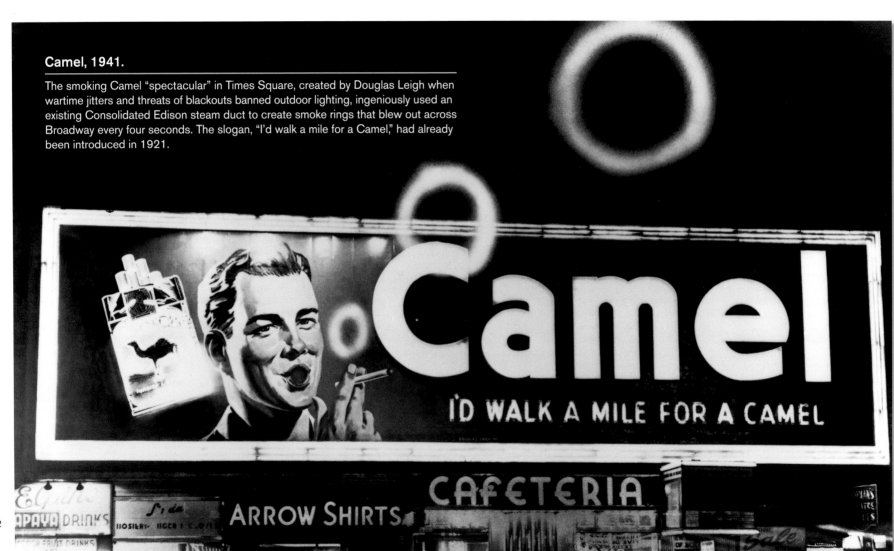

Camel, 1941.

The smoking Camel "spectacular" in Times Square, created by Douglas Leigh when wartime jitters and threats of blackouts banned outdoor lighting, ingeniously used an existing Consolidated Edison steam duct to create smoke rings that blew out across Broadway every four seconds. The slogan, "I'd walk a mile for a Camel," had already been introduced in 1921.

82

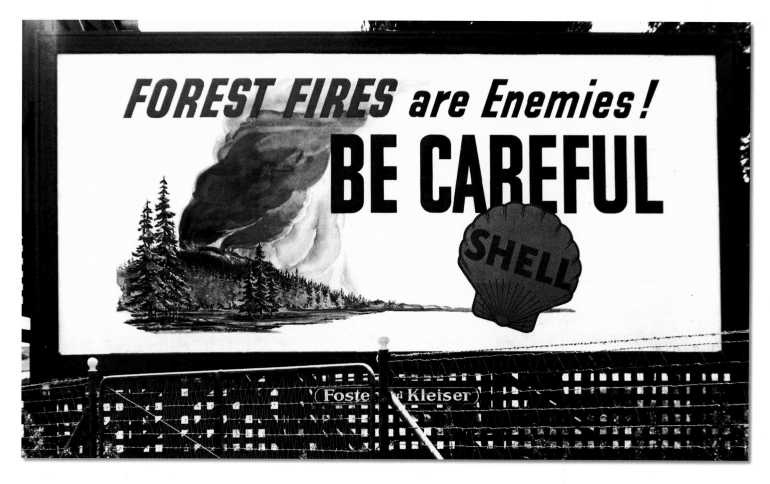

Be Careful, 1941.

Early fire prevention billboard was donated by Shell Oil as a public service, to make the increasing number of motorists more aware when driving through wooded areas.

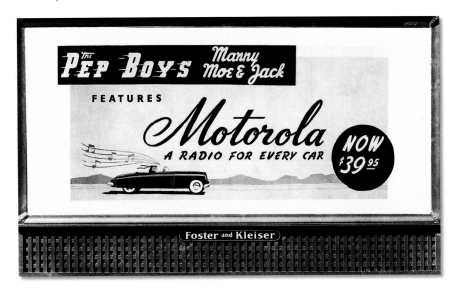

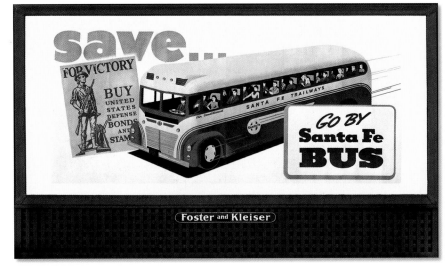

The Pep Boys Features Motorola, 1941.

The Pep Boys, a haven for automotive do-it-yourselfers, teamed with Motorola to promote car radios, which were a luxury for most motorists. New cars were still available in 1941, but civilian production would be halted once war was declared.

Go By Santa Fe Bus, 1941.

The two-fold message was: Save money by traveling with Santa Fe, while saving money by investing in defense bonds and stamps.

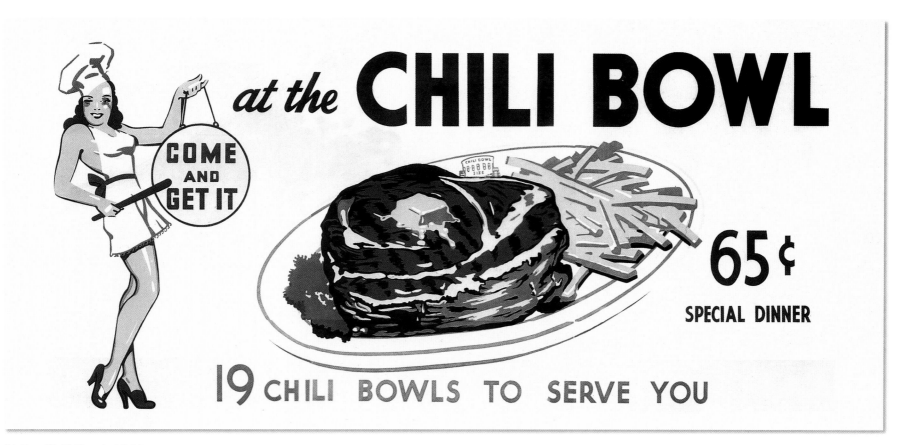

At the Chili Bowl, 1941.

Which was more tempting? The steak and fries or the the "come and get it" come-on?

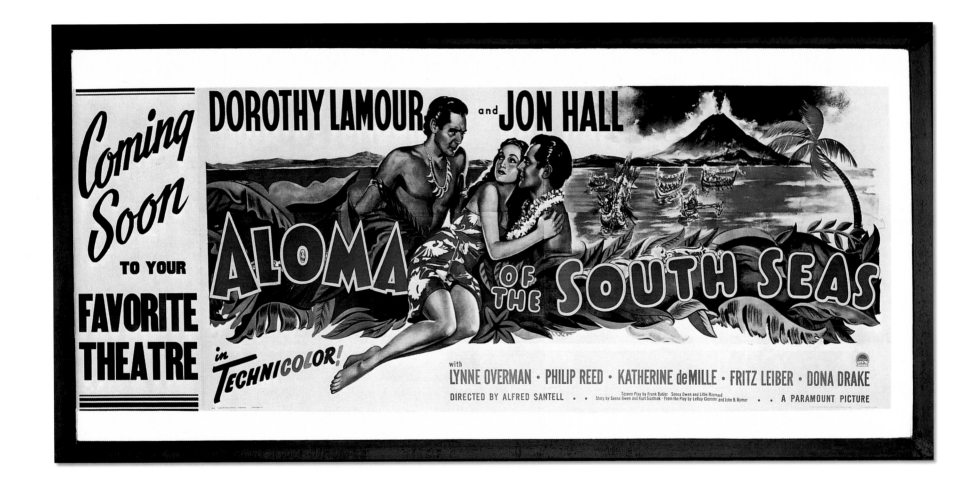

☞ *Aloma of the South Seas,* 1941.

Dorothy Lamour in the sarong that made her famous. The islands of the South Pacific were still thought of as paradise on Earth when the film was released. But December 7th was only a few months away.

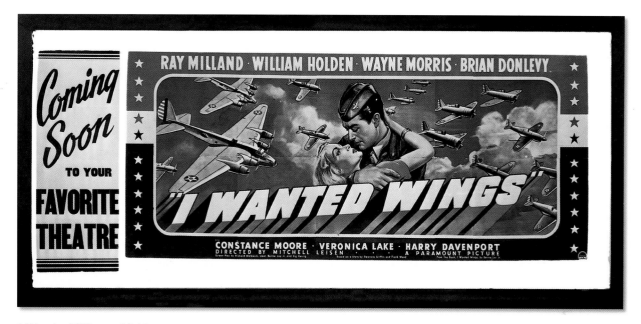

I Wanted Wings, 1941.

A minor film about three recruits in training for the Air Force, made memorable only for its Academy Award–winning special effects and the introduction to the screen of Veronica Lake, whose peek-a-boo blonde tresses became a national fad. Billboard art by McClelland Barclay.

1942–1943

A Nation United

The surprise attack on Pearl Harbor by Japan on the morning of December 7, 1941 immediately plunged the United States into a war that would become the most geographically widespread military conflict the world had ever seen. Most of Europe had already been conquered by Nazi Germany, and Japanese armies were sweeping across Asia and the Pacific. Although America was better prepared for war than it had been twenty-four years earlier, it was still undermanned and underequipped compared to the Axis powers.

By June 1942, Roosevelt had established the Office of War Information (OWI), which produced thousands of posters to support the war effort, to conserve the nation's vital resources, to buy war bonds, and to protect and preserve the national security. Its ambitious goal was to place posters in every city and town across the United States, with new posters replacing the old ones every two weeks. To help distribute the posters, the OWI asked the Outdoor Advertising Association of America (OAAA) to participate in the program. OAAA in turn organized the Outdoor Advertising Committee, which encouraged

members to be responsible for distributing 250,000 one-sheet posters each month. There were precise instructions on how to display the posters. Each billboard was comprised as series of twenty-four sheets pasted contiguously together to form a single image. A single one-sheet poster identifying the Office of War Information was to be placed in the lower right-hand corner of each billboard. Billboards became a potent tool for promoting patriotism, raising morale among civilians and soldiers, and for propaganda purposes.

In addition to the artists who belonged to Outdoor Advertising of America, the Navy organized its own group, which began with approximately 100 members and expanded to nearly 400 artists by the war's end. Unsolicited designs were not accepted. According to protocol, several members were invited to participate on a specific project and each submitted sketches. Once a design was selected, the chosen artist executed his painting. One of the leading Navy artists was McClelland Barclay, known for his magazine covers and for his "Body by Fisher" campaign for General Motors. Barclay began designing posters for the

Navy during World War I. He returned for active duty during World War II, producing a variety of memorable images for nearly three years.

Recruitment posters were aimed not only at attracting volunteers into the armed forces, but with more than 16 million men in uniform, employment opportunities for women at home expanded dramatically. In 1942, a popular song heralded the contributions of a dedicated war plant worker named Rosie. The Rosies of America were often mentioned in the print media. Early in 1943, Rosie appeared on a poster commissioned by the U.S. War Production Department. She was pictured in coveralls with rolled up shirtsleeves, flexing a muscular upraised arm. "We Can Do It!" read the caption. More than six million women joined the American workforce during the war years.

Beginning in 1942, Americans were faced with three years of "Use it up, make it do, wear it out, or do without." Sugar and coffee were among the first products to be rationed, followed by canned meat, canned fish, fresh meat, butter, and cheese. With the best quality products earmarked for the military, substitutes had to be found for civilian consumers. Butter substitute oleomargarine came as a white block of shortening with a small capsule of yellow-orange fluid which was pressed, squeezed, and blended into the oleo until it turned yellow.

One way to get around food shortages was to create a victory garden. Backyards, empty lots, flower gardens, even front lawns were turned into crop-yielding oases on a small scale. Homemakers filled mason jars with homegrown produce and preserves for future use. As the war went on, victory gardens supplied nearly 40 percent of the vegetables consumed on the home front.

The scarcity of cigarettes, which were supplied free to servicemen, created headaches for retailers as more and more civilian smokers cut back. Tobacco companies faced challenges, too. R. J. Reynolds was forced to repackage Lucky Strike Green to white because the green aniline dyes were required to produce olive-drab pigments for uniforms. The Reynolds' marketing department cleverly turned the change in packaging into a patriotic slogan: "Lucky Strike Green has gone to war."

New cars became an increasingly rare sight after civilian automobile production ceased in 1942. When gasoline went on the rationed list, and new tires were impossible to obtain, the national speed limit was reduced to 35 miles per hour. The enforced slow-down was a bonus for outdoor advertisers, as it gave motorists time for more than a speedy glance at roadside billboards.

Shortages at home and the news from overseas meant everyone needed an escape from reality, if only for a few hours. Nightclub attendance soared by 100 percent. Movie attendance climbed as well, despite, or perhaps because of, male stars enlisting in the armed forces. The absence of leading men opened the door for a crop of beautiful ladies, pin-up girls who raised war-weary spirits and kept box offices humming.

The end of the war came in 1945 following unrelenting Allied advances in Europe and mushroom clouds rising over Hiroshima and Nagasaki. How easy the transition to peace would be, no one could predict. But Americans were eager to find out.

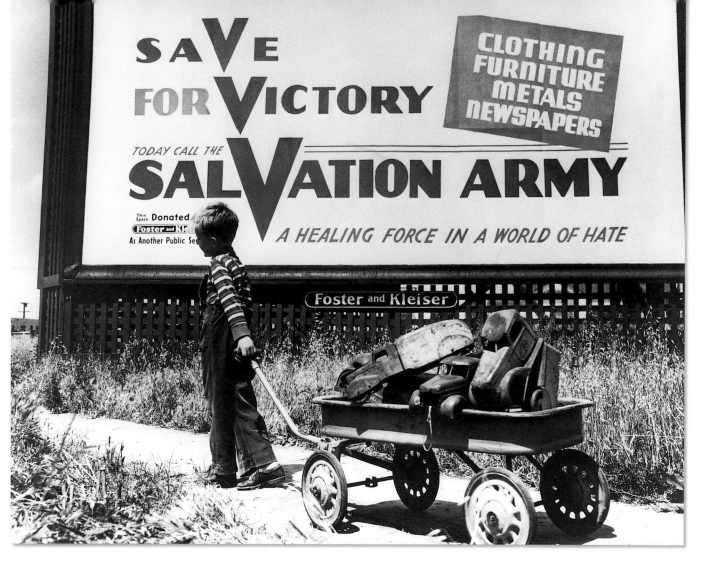

Salvation Army, 1942.

This billboard, with its three Vs for victory, certainly attracted attention during the early years of the war, but it gained fame when this staged photo of a youngster sacrificing his precious toys to help the war appeared on front pages across America.

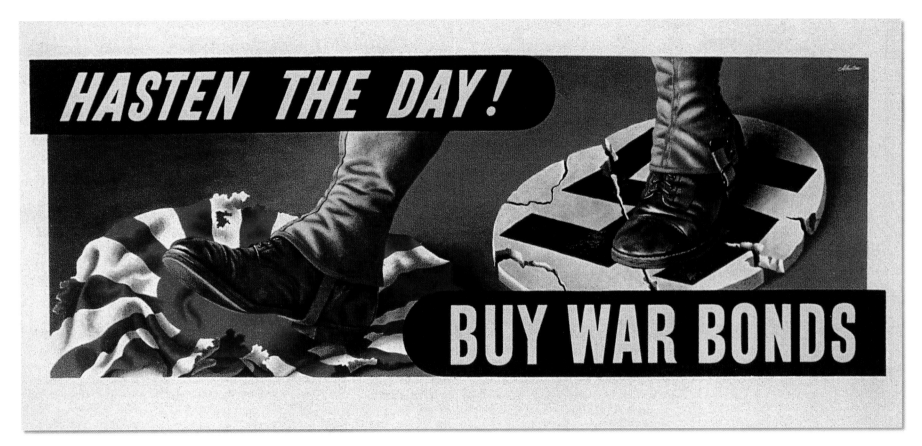

Hasten the Day! Buy War Bonds, 1941.

The message is almost incidental to the overwhelming power of the graphic.

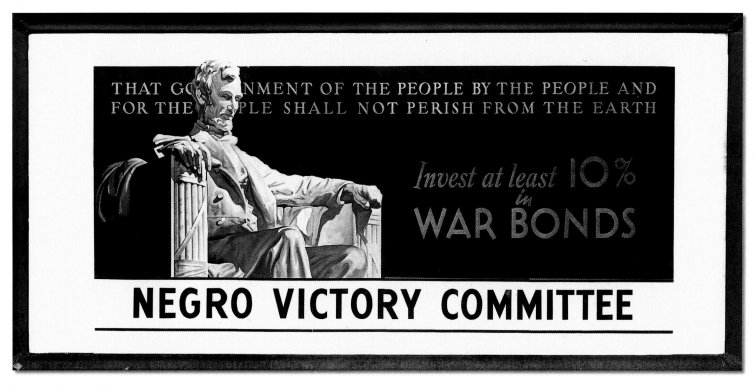

THAT GOVERNMENT OF THE PEOPLE BY THE PEOPLE AND FOR THE PEOPLE SHALL NOT PERISH FROM THE EARTH

Invest at least 10% in WAR BONDS

NEGRO VICTORY COMMITTEE

Negro Victory Committee, 1942.

Formed in 1941 by Reverend Clayton Russell, the Negro Victory Committee included public officials, union leaders, professionals, and NAACP members who worked to create jobs for blacks in defense plants.

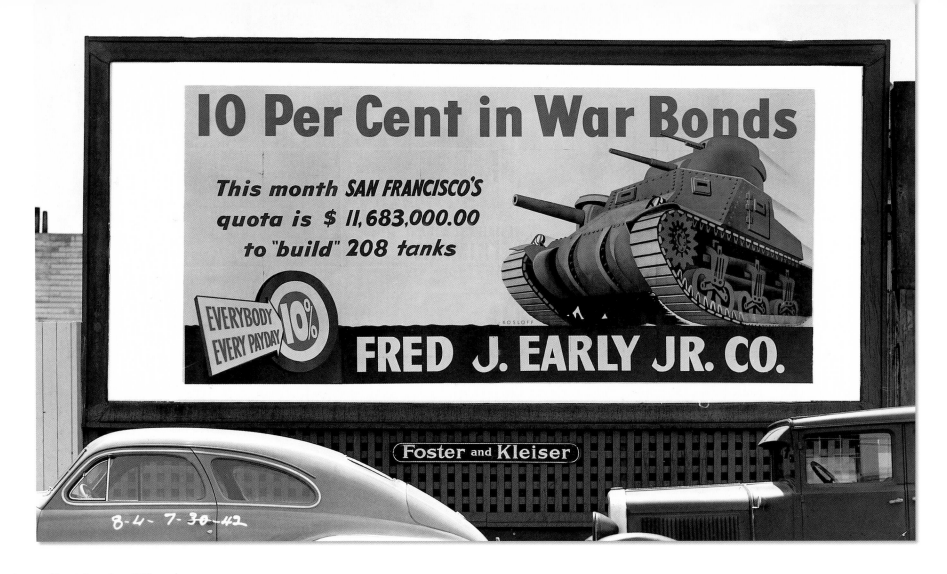

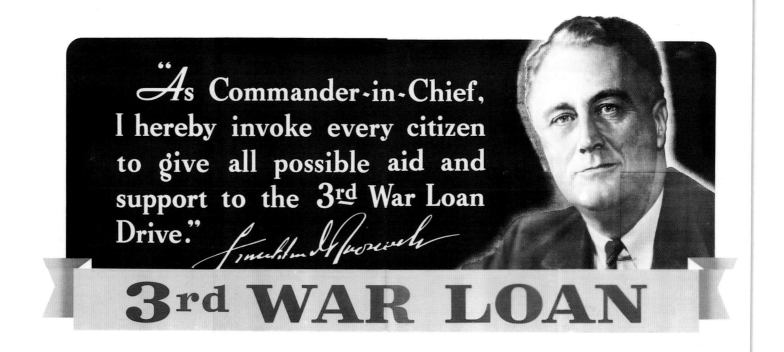

10 Per Cent
in War Bonds,
1942.

Many cities set quotas
for their fundraising
efforts, which created
a sense of urgency and
immediacy with the
public.

3rd War Loan, 1943.

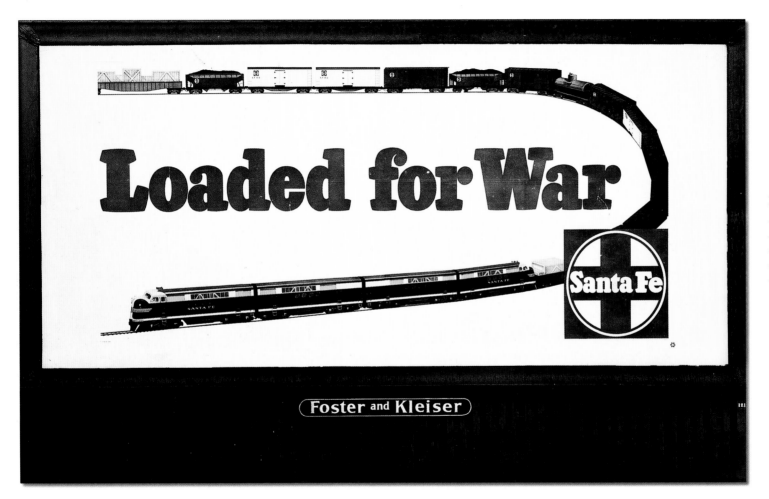

Loaded for War, 1942.

Virtually every industry wanted to be identified in the public's mind with the war effort. The travel and transportation industries were no exception.

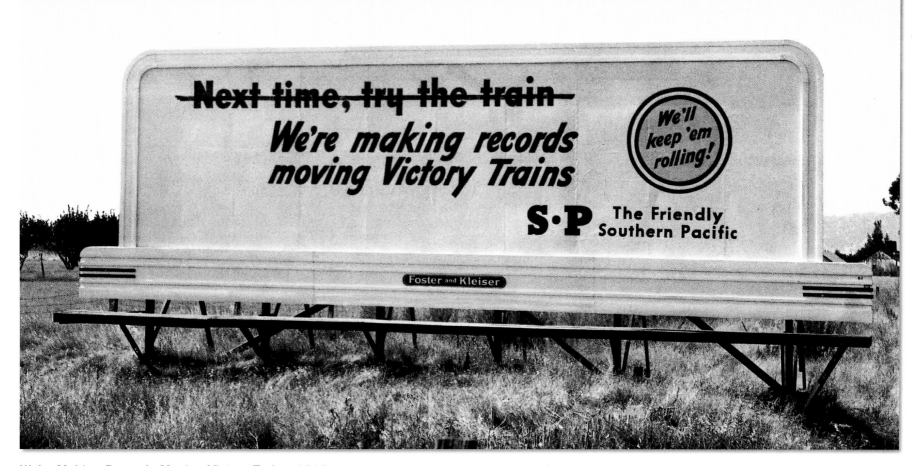

We're Making Records Moving Victory Trains, 1943.

The Southern Pacific railway temporarily suspended its famous slogan, "Next Time, Try the Train," to let the country know it was now handling wartime supplies and equipment instead of passengers.

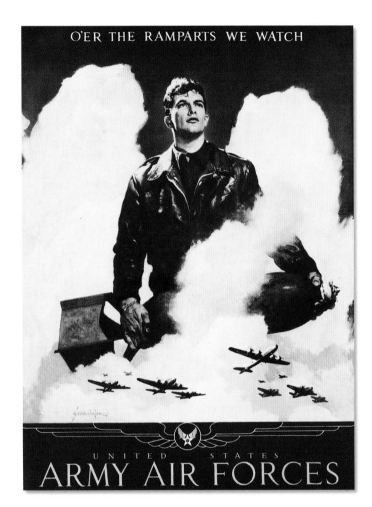

O'ER THE RAMPARTS WE WATCH

UNITED STATES
ARMY AIR FORCES

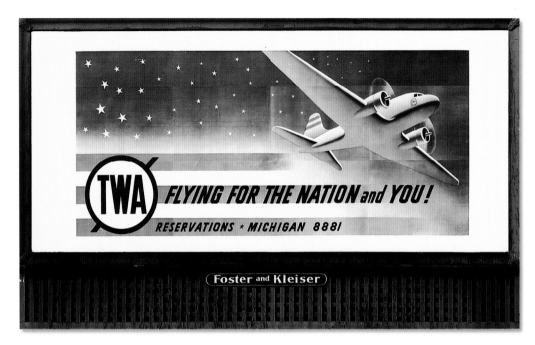

TWA, 1942.

☞ Army Air Forces, poster, 1942.

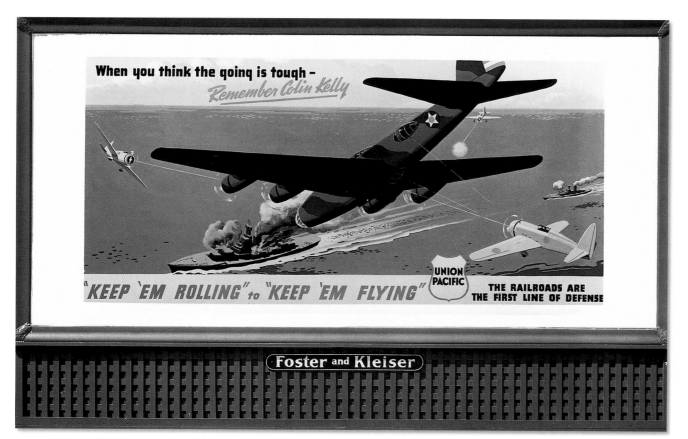

When You Think the Going Is Tough, 1942.

Union Pacific sponsored this billboard dedicated to Colin Kelly, America's first aviation hero of World War II. Just three days after the attack on Pearl Harbor, Captain Kelly and his crew were on a secret mission in the South Pacific. As they attacked an enemy warship, their B-17 was hit by Zero fighters. Kelly ordered the crew to bail out while he remained with the doomed bomber, sacrificing his own life to save his men.

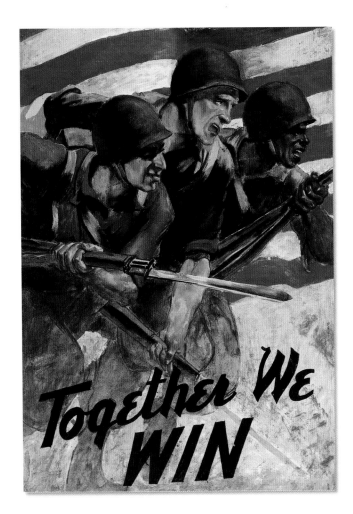

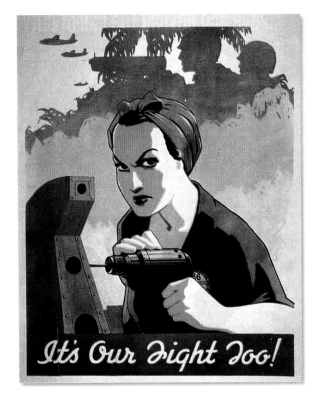

It's Our Fight Too, poster, 1942.

An icon of American women on the production lines in munitions factories, Rosie the Riveter was everywhere—on posters, in newsreels—rolling up her sleeves. Her home-front heroism opened up job and career opportunities for American women during and after the war. A Rosie the Riveter memorial in Richmond, California, honors the women who worked in the Northern California shipyards.

Together We Win, poster, 1942.

Many advertisers donated display space and materials in various media to help raise money and morale throughout the war years.

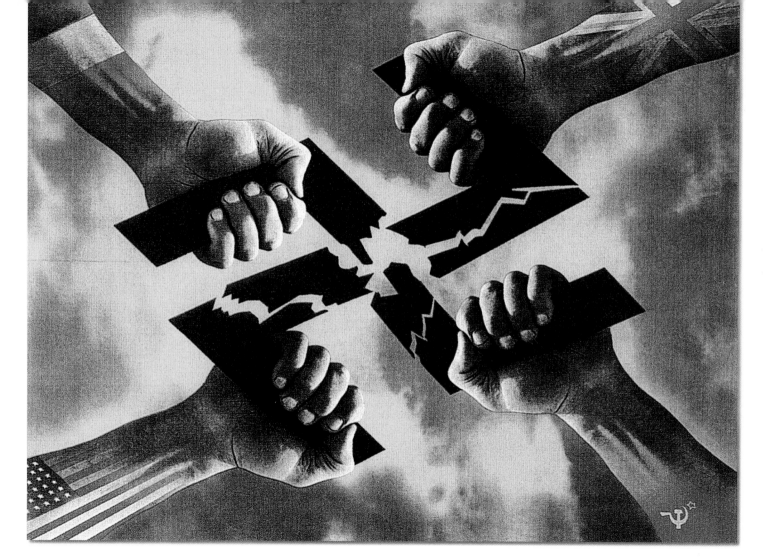

**Allies Shatter Swastika,
poster, 1942.**

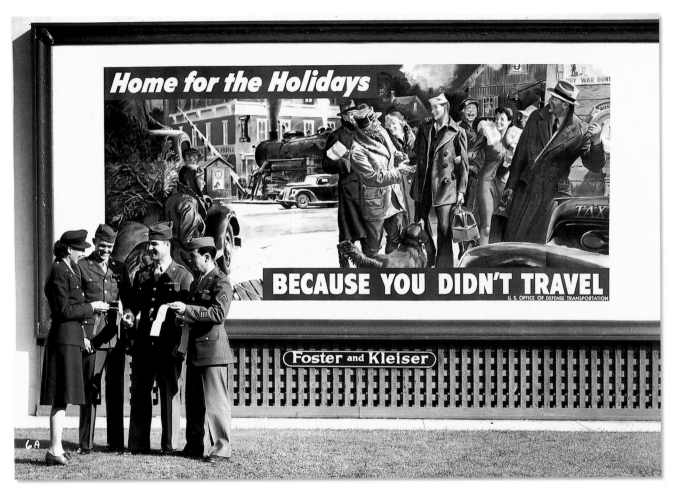

☞ **Home for the Holidays, 1942.**

Like a publicity still for a movie, the Office of War Information (OWI) released images intended to sell Americans on the idea that even small sacrifices directly served the interest of servicemen and women.

Give *Your* Blood, 1942. ☞

Deceptively simple at first glance, this billboard carries a subtle, yet high impact message that compares civilian blood donation to the "ultimate sacrifice" by military personnel.

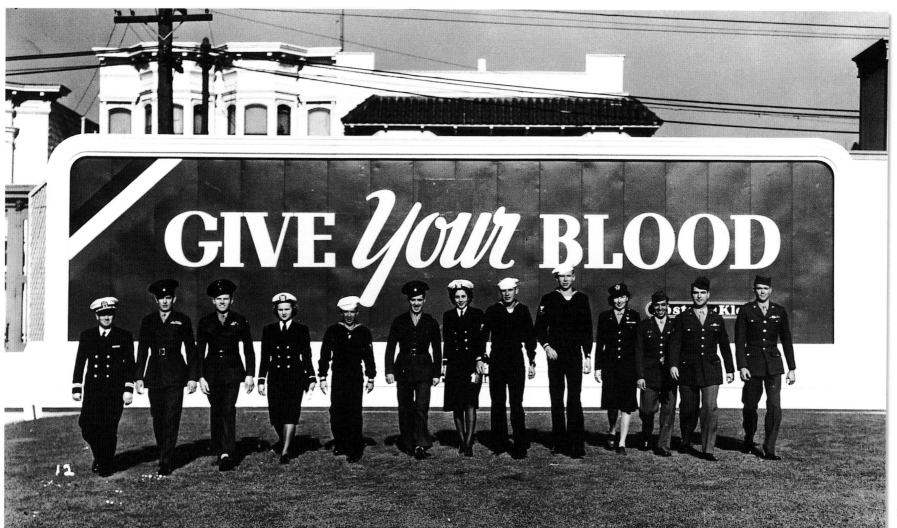

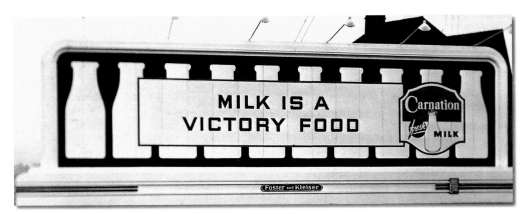

☞❚ Milk Is a Victory Food, 1942.

Carnation brand promotes its products as essential to the cause.

Rathjens Frankfurters, 1943.

Hot dogs, Spam, and other processed meats became staples in the American wartime diet as the best grades of beef were reserved for the men and women in uniform.

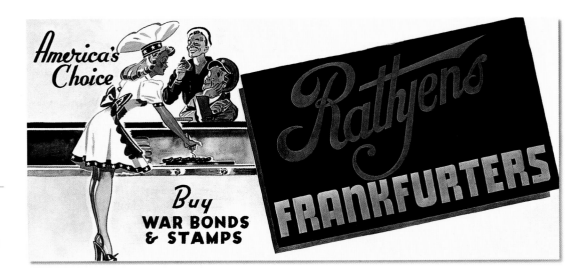

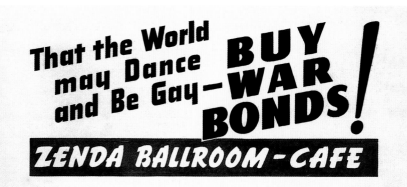

👉 That the World May Dance and Be Gay, 1943.

REGISTER FOR RATIONING MAY 4-5-6-7 APPLY AT LOCAL GRADE SCHOOLS FOR WAR RATION BOOKS

DONATED BY SHELL OIL COMPANY, INC. and FOSTER & KLEISER COMPANY

Register for Rationing, 1942.

Example of a donated billboard (by Foster & Kleiser) with corporate sponsorhip for the message (by Shell Oil).

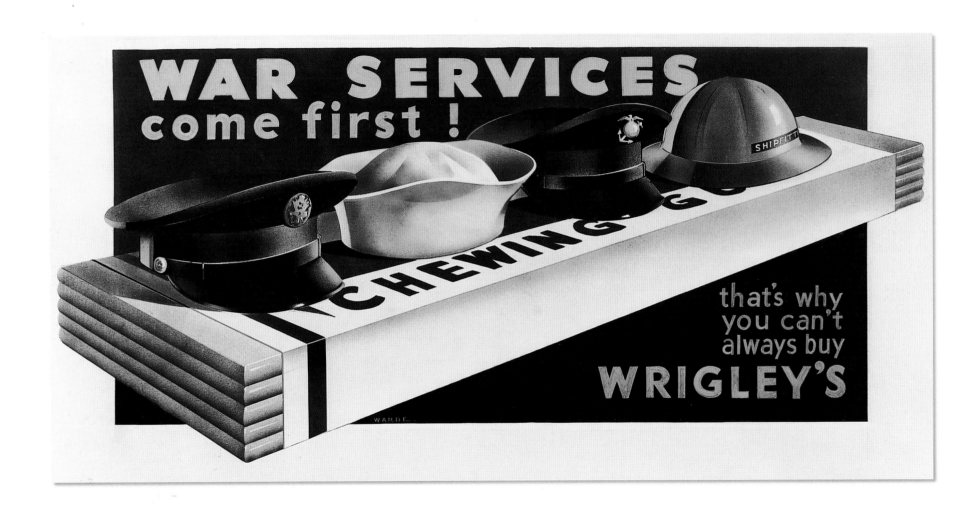

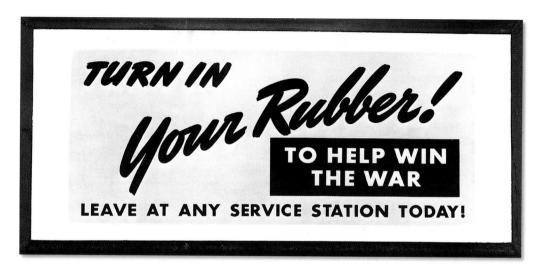

Turn in Your Rubber, 1942.

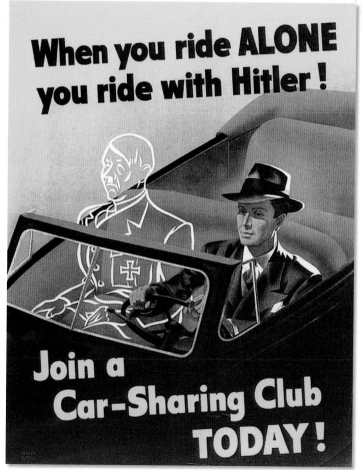

War Services Come First, 1942.

Many popular products were often in short supply, although they were not rationed. The best, and most popular, were earmarked for the armed forces.

When You Ride Alone, ☞ poster, 1943.

Fear and guilt were not uncommon tactics used to encourage patriotic behavior.

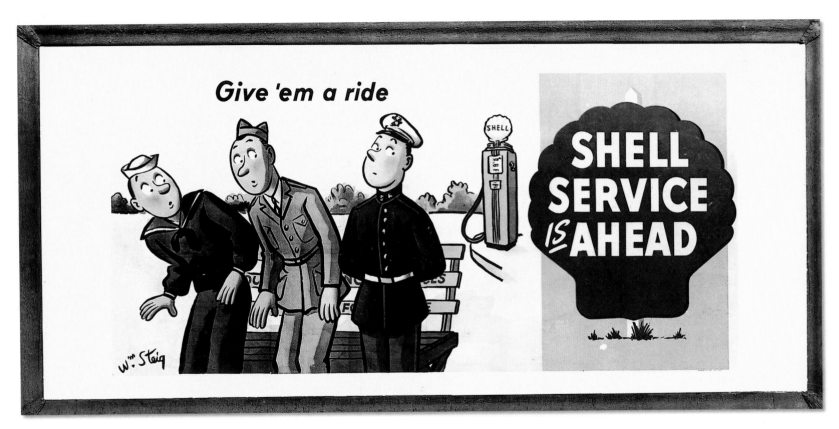

Give 'em a Ride, 1943.

Popular *New Yorker* cartoonist William Steig donated his services to this campaign, also supported with corporate sponsorship.

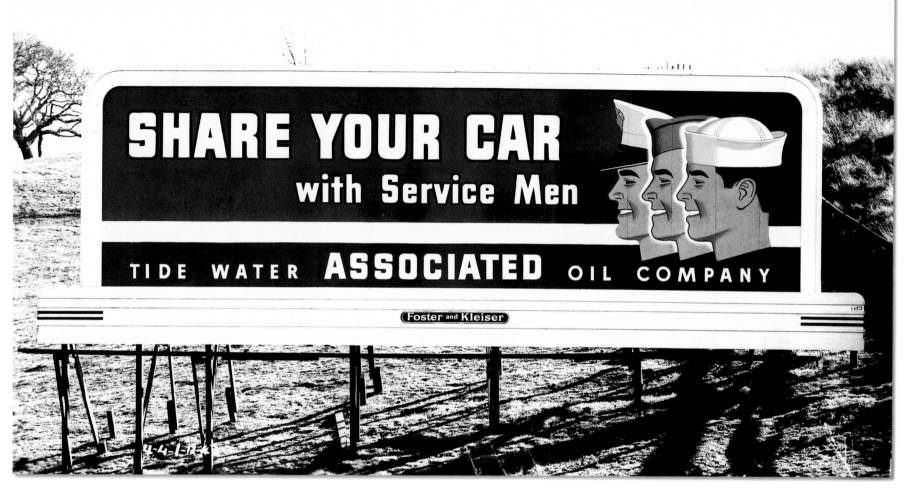

Share Your Car with Servicemen, 1943.

Another patriotic message made possible through corporate sponsorship.

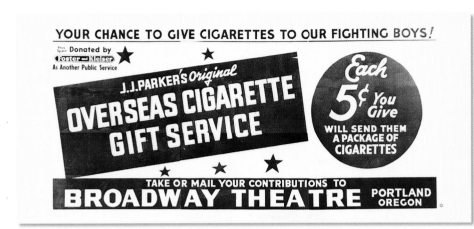

☞ Overseas Cigarette Gift Service, 1943.

Smash the Axis Pay Your Taxes, 1943.

Smash the Axis Pay your taxes

INCOME TAXES DUE
MARCH 16TH *Pay Early!*

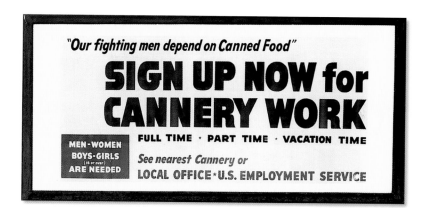

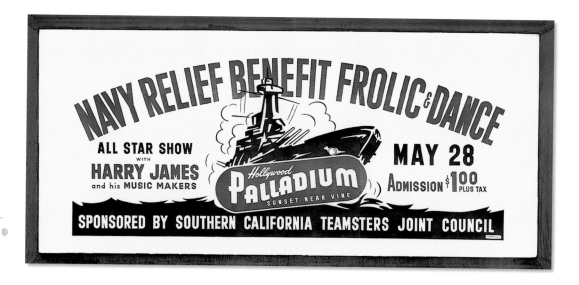

👉 Sign Up Now for Cannery Work, 1943.

Note that not only are men and women urged to sign up, but teenagers also are encouraged to join the work force.

Navy Relief Benefit Frolic & Dance, 1943.

The teamsters union sponsored this billboard. Unions formed in the wake of the Great Depression continued to gain power and influence throughout the war years.

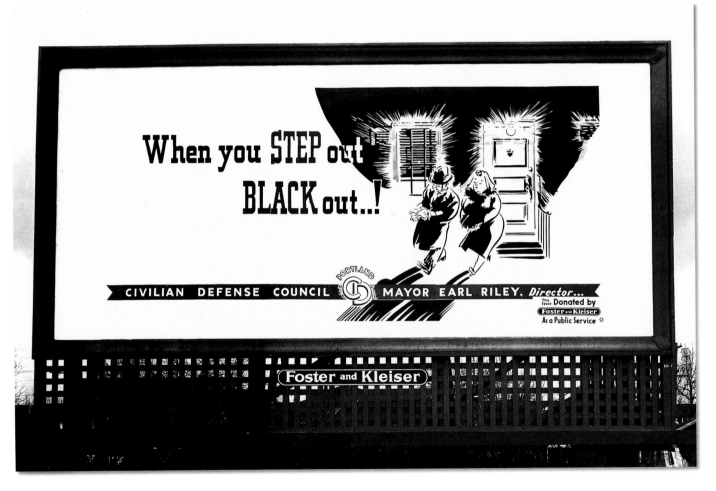

**When You Step Out–
Black Out, 1943.**

Following the attack on Pearl Harbor, there were fears of bomb attacks along America's coastlines, where even striking a match could be seen from miles away. Black-outs and dim-outs were imposed during curfew times.

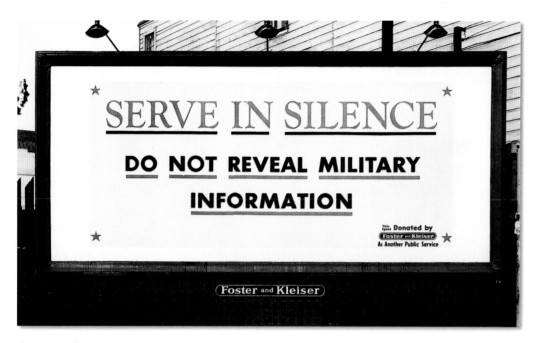

Serve in Silence, 1943.

Foster & Kleiser donated a great number of billboards to the OWI for public service messages.

... Because Somebody Talked, poster, 1943. ☞

This touching image was a reminder that "loose lips sink ships," a motto created to strengthen national security during World War I. A gold star on a flag signified the loss of a family member in the armed services.

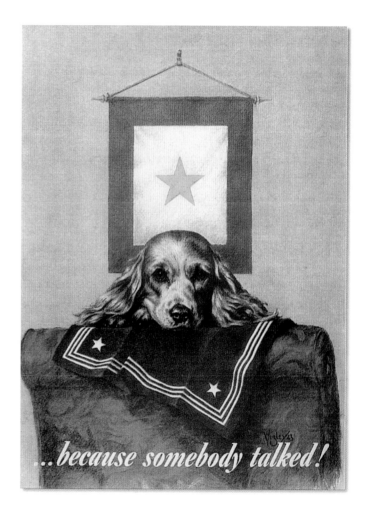

1944—1949

A Celebration

As World War II came to a close, newspapers warned that the nation would be poorly prepared should the fighting suddenly stop. "It is a fact that our transition and reconversion plans seem to be moving so slowly," one reporter noted, "as to indicate a time-table calling for another year or two of war in the Pacific." It was feared there would be delays in obtaining materials, equipment, and manpower to meet expected demands.

Such dire predictions, coupled with the sudden death of President Roosevelt on April 13, only a few months after being sworn into office for an unprecedented fourth term, had the nation on edge. Roosevelt's successor, Harry S. Truman, tried to calm the public's nerves by telling Congress, "In the difficult days ahead, with the faith of our fathers in our hearts, we do not fear the future."

As it turned out, the future would be brighter than it had been in nearly two decades. Servicemen were returning home, their pockets filled with cash, many of them eager to get married, start families, and begin new lives. At home, those who had been "making do" for so long were now in a spending mood—and no wonder. The public was being bombarded with tempting advertisements in newspapers, over the radio, on billboards, even by the new medium of television. Manufacturers were opening hundreds of retail outlets, and their mail order catalogs were thriving. Grocery stores were becoming supermarkets, and spending more than $800 million on regional branches, many of them in newly built shopping centers. Drug stores were also adopting the self-service, over-the-counter pattern.

But not everything that was being advertised was immediately available. Many showrooms were empty and there were waiting lists for high-ticket items, such as large household appliances, cars, and television sets as manufacturers retooled from wartime to peacetime production. (In 1945, there were roughly 10,000 TVs in the United States. But by 1949 that figure had zoomed to one million, despite the lack of programming.)

Advertising budgets skyrocketed to attract a nation of eager buyers, particularly as the decade drew to a close. Ad agencies expanded to service the growing needs of their clients. The future looked bright for most of America despite signs that the United States and the Soviet Union were drifting inexorably toward a Cold War. At home the landscape was still sunny. And the best was yet to come.

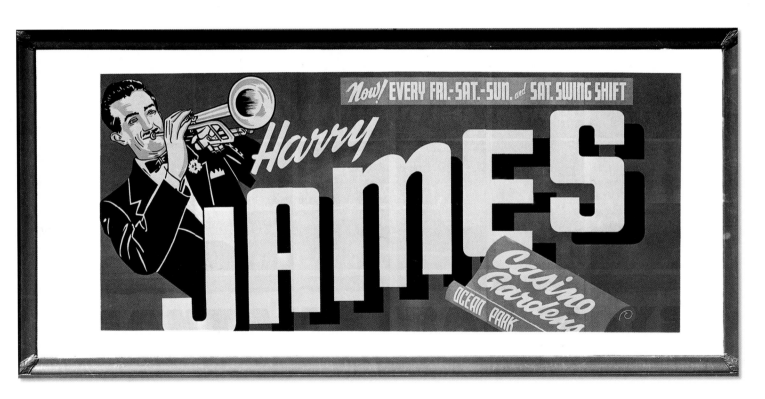

Harry James, 1944.

One of America's top bandleaders and instrumentalists, Harry James drew crowds wherever he appeared with his trumpet and orchestra. During the war years he was also seen in several movie musicals, including *Spring Time in the Rockies,* which starred the GI's number one pin-up girl, Betty Grable, who became Mrs. Harry James.

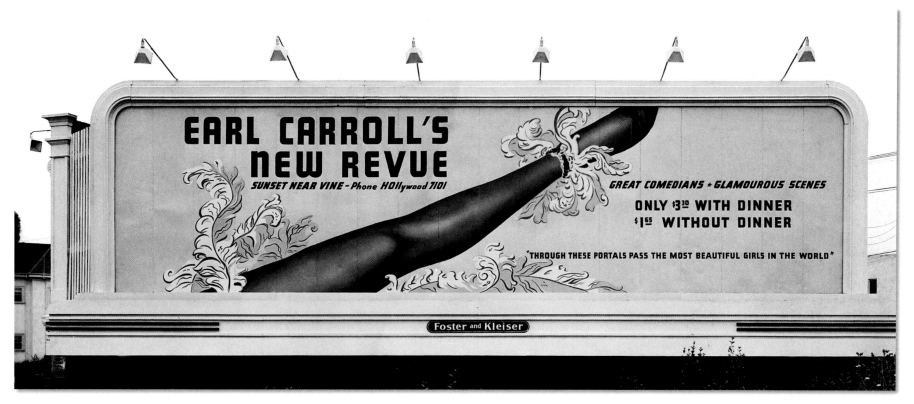

Earl Carroll's New Review, 1945.

First postwar revue for the bi-coastal showman promised what nightclubbing audiences expected: lots of girls! girls! girls! The shapely leg extending across the long board made excellent use of the elongated space.

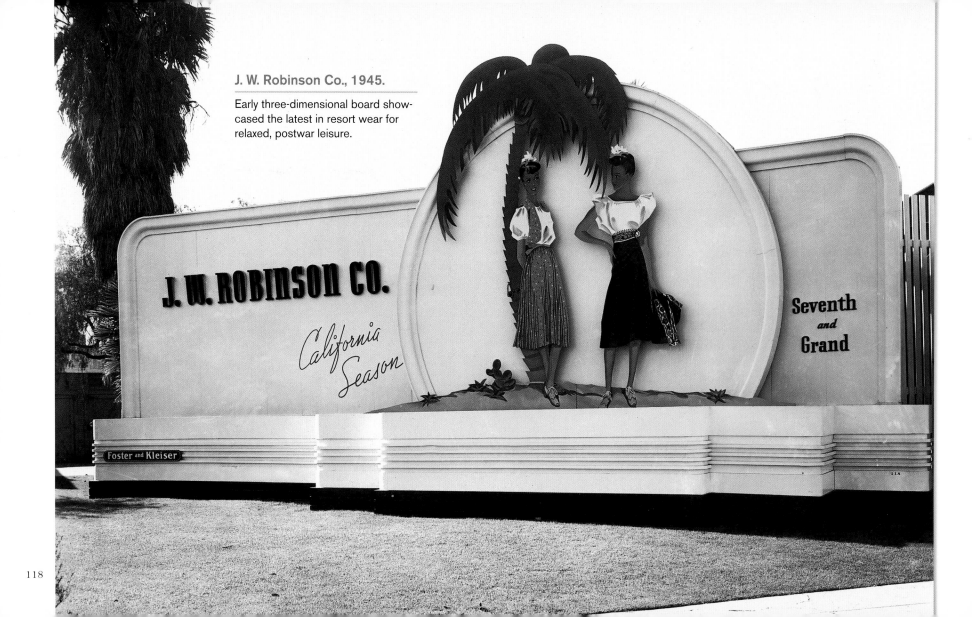

J. W. Robinson Co., 1945.

Early three-dimensional board showcased the latest in resort wear for relaxed, postwar leisure.

J. W. ROBINSON CO.

California Season

Seventh *and* Grand

Foster *and* Kleiser

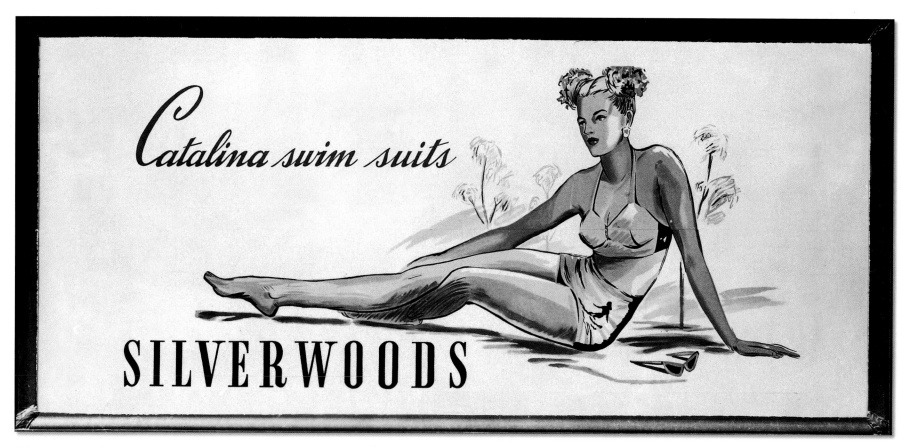

Silverwoods, 1946.

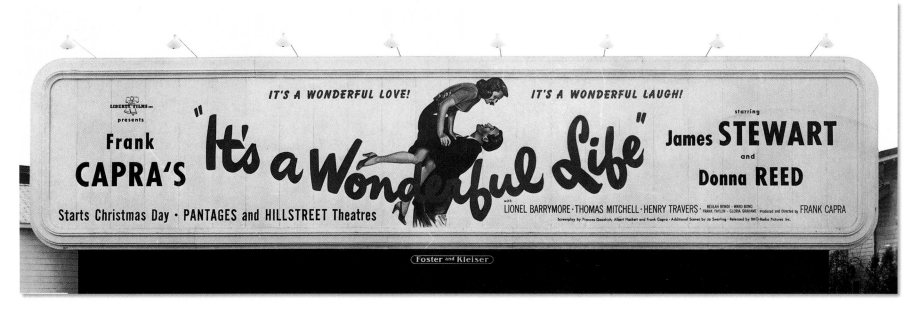

It's a Wonderful Life, 1946.

Frank Capra's sentimental Oscar-winning film opened on Christmas Day but was not a box-office success despite its message of gratitude and optimism. Thanks to television, it has since become an annual holiday favorite. The film's original storyline was inspired by a Christmas card.

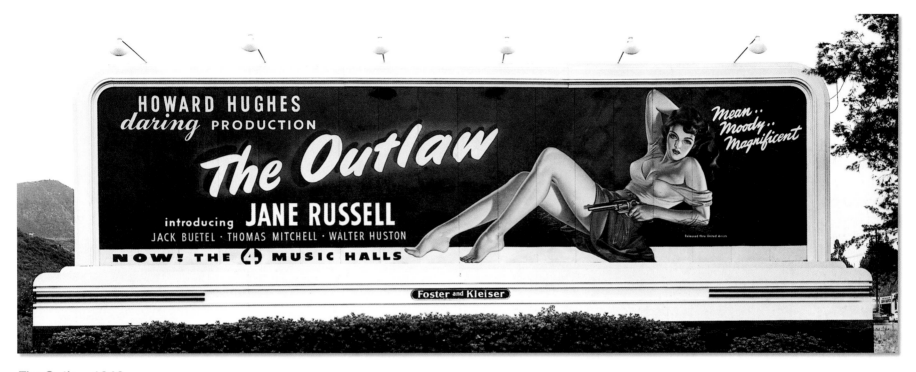

The Outlaw, 1946.

The long-delayed, censor-plagued movie starring Howard Hughes protégé Jane Russell was more famous for its advertising than its actual content. Artwork by Ren Wicks for the second billboard was personally commissioned by Hughes after the original billboard, dominated by an even more suggestive image of the actress, was protested by church groups and decency leagues. The image caused such a furor in some cities, including San Francisco, it was banned until a more acceptable (above) version replaced it.

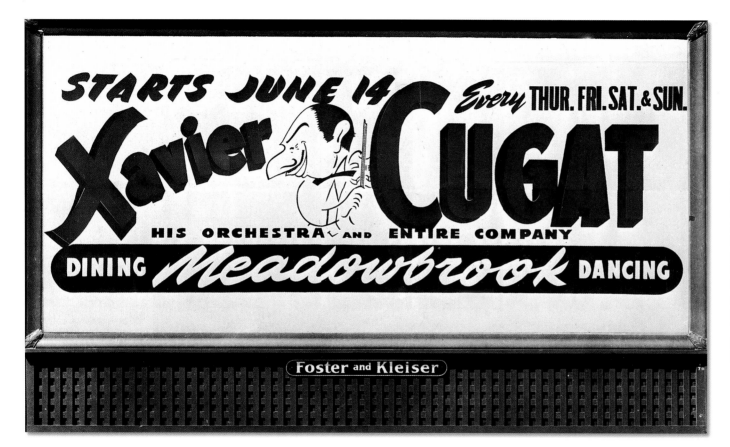

STARTS JUNE 14 Every THUR. FRI. SAT. & SUN.

Xavier CUGAT

HIS ORCHESTRA AND ENTIRE COMPANY

DINING Meadowbrook DANCING

Foster and Kleiser

Xavier Cugat, 1946.

America's "Rhumba King" helped popularize Latin music throughout the United States. His suave appearance, the chihuahua he always carried in his arms, and his roles in popular musicals of the 1940s earned him widespread fame. A former cartoonist for the *Los Angeles Times*, Cugat was also known for his celebrity caricatures, including his own.

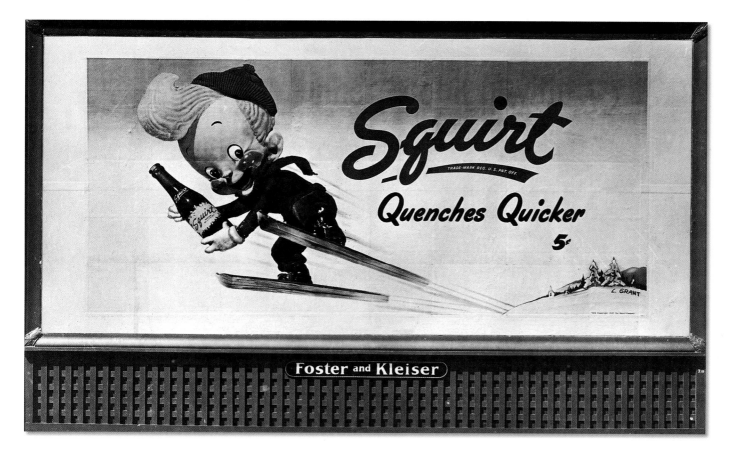

Squirt, 1947.

Mascot for a citrus-fresh soda bears a close resemblance to Speedy, the Alka-Seltzer icon launched in 1951.

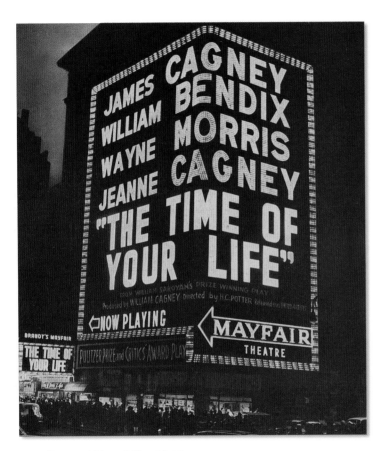

The Time of Your Life, 1948.

After years of blackouts, the "Great White Way" came to life again.

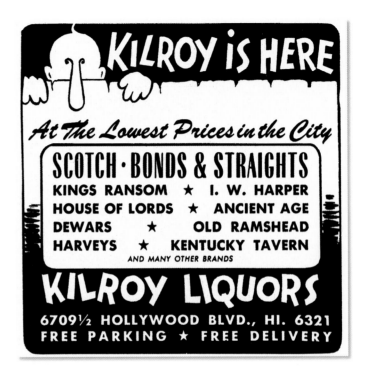

Kilroy is Here, 1947.

During World War II, the enigmatic cartoon character of Kilroy, always accompanied by the line "Kilroy was here," began to appear wherever the American military traveled abroad, and also materialized as graffiti at home. It wasn't long before the ubiquitous Kilroy came to represent America's worldwide presence. There are various explanations surrounding Kilroy's origins, however, one popular theory promoted by some WWII veterans claim he was a shipyard inspector in Boston who scrawled the phrase on bulkheads during his rounds.

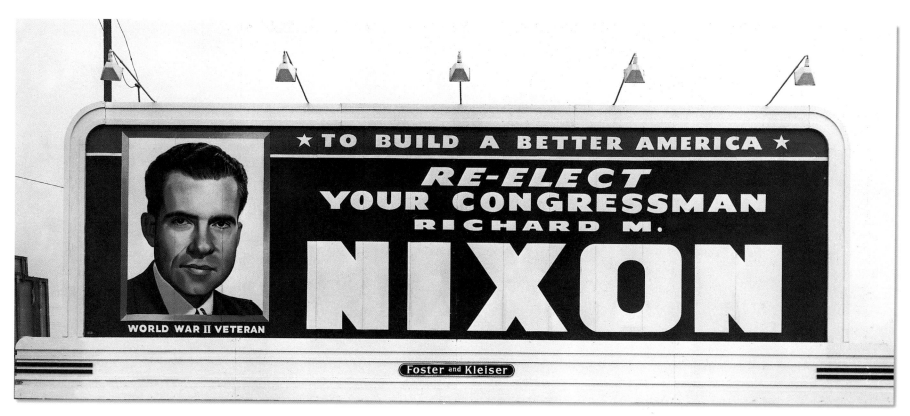

Re-elect Nixon, 1948.

After serving with distinction in World War II, where he rose to the rank of lieutenant commander, Richard M. Nixon was re-elected to the U.S. House of Representatives from California.

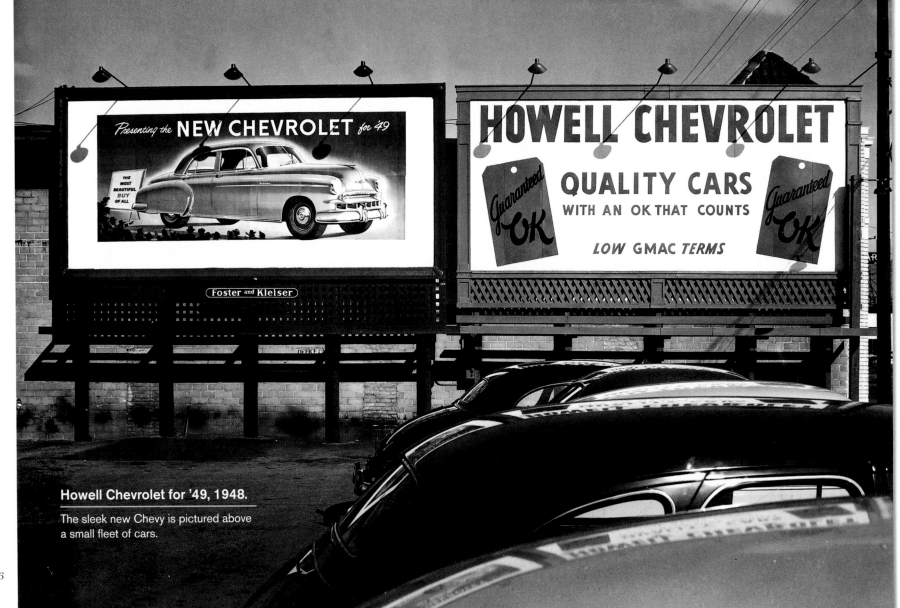

Howell Chevrolet for '49, 1948.

The sleek new Chevy is pictured above
a small fleet of cars.

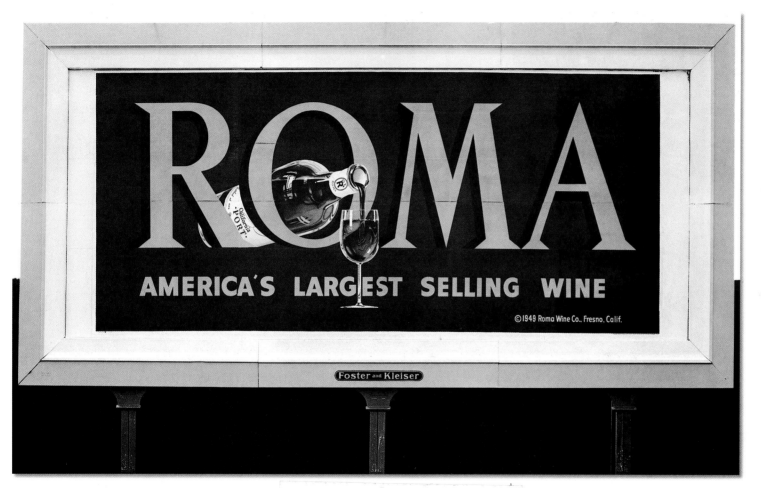

Roma, 1949.

Clever three-dimensionality in advertising graphics was an effective way to grab viewer attention.

Indian Prairie Public Library District
401 Plainfield Road ~ Darien, IL 60561

1950–1959

Outdoor Advertising Grows Up

The good times were already rolling by the time the Eisenhower administration got underway in 1952. The 1950s would be dubbed the era of the "Affluent Society" as the post-war spending spree continued, paced by the automobile industry with sales of 12 million cars and backed by a record $400 million spent in advertising.

This was the golden age of the great, gas-guzzling (at 27 cents a gallon) classic sedans that didn't stint on size or style. However, the sportier European models were making their mark, and American automakers took note. The first Corvette rolled off the line in 1953 with a wrap-around windshield and a continental look. It sold for a pricey $3,513—nearly $200 more than the popular English import, Jaguar XK120. And a little-known German automaker, Volkswagen, began to market an odd-looking, rear-engine little car called a Beetle.

Many Americans had leisure time for the first time in their lives, and the more time they had the more they wanted to do and buy. And thanks to technological advances leftover from wartime, American manufacturers were geared up to give consumers what they wanted: No more heavy, breakable bottled beer—Budweiser touted its light-weight, easy-to-carry cans to suit every active lifestyle; frosty pitchers of fruit juice appeared from powdered packets—just add water; and ham was pressed and packaged into perfect rolls—ready to slice and serve.

Leisure time meant a need for new outlets for recreation. The 1950s introduced novelties like the hula-hoop, 920 million of which were sold within its first four months on the market. Also the Frisbee, Slinky, Silly Putty, and Barbie—all of which are still with us today. Disneyland opened its doors in 1955. Elvis Presley transformed rockabilly music into rock n' roll, which turned youngsters into teenagers. And Madison Avenue turned teenagers into the latest consumers.

The pin-up girls of the 1940s had made "cheesecake" ads enormously popular. As the trend continued throughout the '50s, *Playboy* magazine found a vast adult audience all its own. By contrast, Hollywood was struggling thanks to early advances in broadcast technology, which turned television from a moderately diverting novelty into *the* dominant media.

As new companies brought new brands to the marketplace, advertisers were increasingly challenged to give each product a memorable identity. One way, proven during both world wars, was the creation and continuing use of a single iconic image with a readily recognizable persona. Creative ad men of the '50s put a fun-loving spin on this concept by making their icons easy to relate to and lovable. And advertising expenditures soared, exceeding $10 billion during the decade.

In the billboard business, the introduction of cutout images extending beyond the standard framework became a major trend. What started rather simply with small, ornamental extensions soon grew into larger and more extreme features that eventually became the dominant attraction. Initially, cutout extensions were constructed onsite. However, in time, the segmented billboard comprised of twelve four-foot-wide panels became a standard format, which allowed for the board not only to be painted at the plant (or studio) then installed onsite, but also to be rotated to various other locations.

The 1950s also took Americans to another distant shore when Communist forces invaded South Korea and U.S. troops were sent as part of a United Nations force commanded by General Douglas MacAr-thur. By the end of 1953, the so-called "police action" had claimed the lives of more than 54,000 American servicemen and women.

America's relationship with the Soviet Union grew increasingly cool as the arms race heated up, particularly after the Russians successfully tested their own atomic bomb in 1949. Backyard bomb shelters proliferated all over the country in response to imagined immanent nuclear attack from the Soviets.

And Wisconsin Senator Joseph McCarthy led a crusade against alleged homegrown Communists and Soviet sympathizers, singling out prominent Americans in high-profile occupations of politics and entertainment for his witch hunt.

On December 1, 1955, in Montgomery, Alabama, a black seamstress named Rosa Parks defied local law and refused to surrender her seat to a white man and move to the back of the bus. African Americans all over the South began to organize and protest the discrimination they faced, encouraged by the words and example of an inspiring young preacher, Martin Luther King, Jr.

Petri Wine Co., San Francisco Calif.

☞ **Petri Wine, 1950.**

Dogs have always been popular in advertising. Note the differences between this remorseful spaniel, with his naturalistically rendered fur, waiting patiently for forgiveness at his master's door, and the highly stylized generic pooch brazenly ready to devour the dog food in the Ken-L-Ration ad—what a difference five years make.

Ken-L-Ration, 1956.

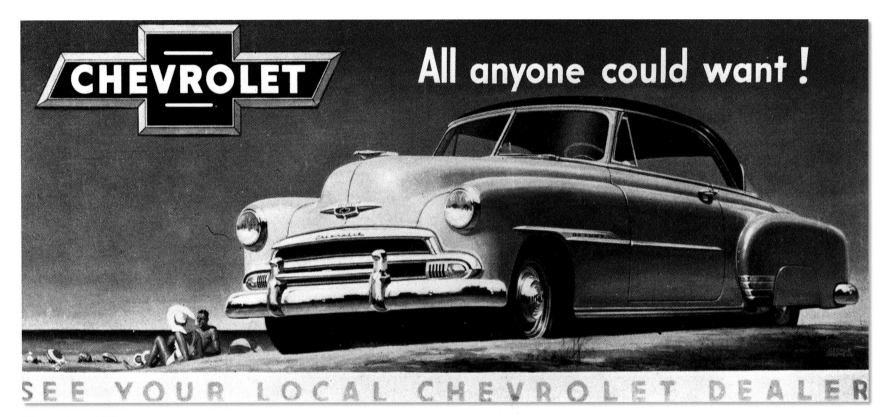

Chevrolet, 1950.

A classic board presenting a classic car—the perfect choice for middle class Americans with leisure time for trips to the beach. The image is extremely successful in its simplicity, conveying an unbeatable message of reliability with power.

Smooth Power, circa 1950s.

Flood along Missouri's Grand River brought a roadside billboard for gasoline eerily to life.

Pepsi-Cola, Times Square, 1953.

Douglas Leigh, the designer who created many of Broadway's most innovative advertising displays, developed the world's largest "spectacular" for Pepsi-Cola in 1953. Stretching a block wide with 50-foot-tall porcelain Pepsi bottles and a 50-foot-tall bottle cap in the center, the sign was lit with over 35,000 lights and more than a mile of neon tubing. The biggest attention-getter, however, was a waterfall that circulated 50,000 gallons of fake soda a minute, which cascaded down between the bottles and disappeared behind the slogan, "The Light Refreshment."

Four Roses, 1953.

Sergeant Major Elmer Bender waves to the crowd as the Armed Forces Day parade passes the landmark Four Roses sign overlooking Grant Park on Michigan Avenue in Chicago.

Kool-Aid, 1954.

The deceptively simple award-winning board was created by John Howard, and cleverly stressed thirst appeal with the frosty pitcher "sweating" coolness.

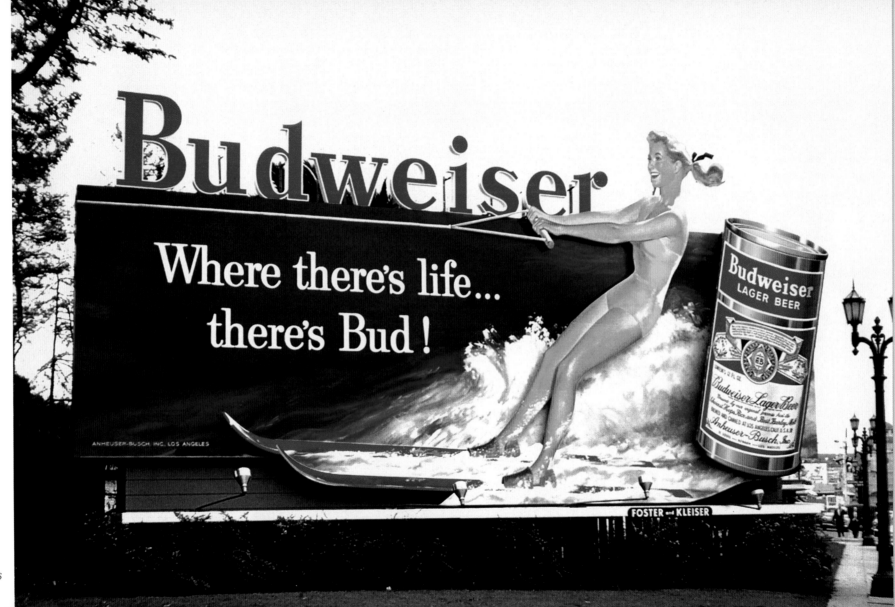

☞ Budweiser, 1954.

A sun-kissed California beauty seems to ski right off the sign into downtown Los Angeles! This remarkably dynamic billboard successfully conveys the fun and freshness of youth and the associated cultural cool of Budweiser. It also captured the attention of the female market, a group that advertisers had previously largely ignored with regard to alcohol, which was seen as a "male" product. Produced in the same year as the Times Square Budweiser spectacular, this is an example of how the same product was promoted differently on different coasts to different audiences.

Iris Coffee, 1956.

The warmth and aroma of Iris brand coffee was achieved by the artists of this board who carefully rendered fragrant steam wafting from each cup. Images that extended beyond the conventionally rectangular framework of the sign also added impact.

Kellogg's Sugar Frosted Flakes, 1957.

Tony the Tiger, created in 1952 for Kellogg's Frosted Flakes, originally shared package panels with Katy the Kangaroo, but Tony became more popular and Katy was retired in 1953. Tony is *the* most recognized animal icon in advertising history.

Rescue 100,000 Lives, 1957.

Not all billboards from the 1950s were dedicated to commerce. Some carried sobering messages and represented the views and ideals of serious causes, such as this board, donated by Foster and Kleiser, that addressed Cold War reality for many Americans with family in Eastern Europe.

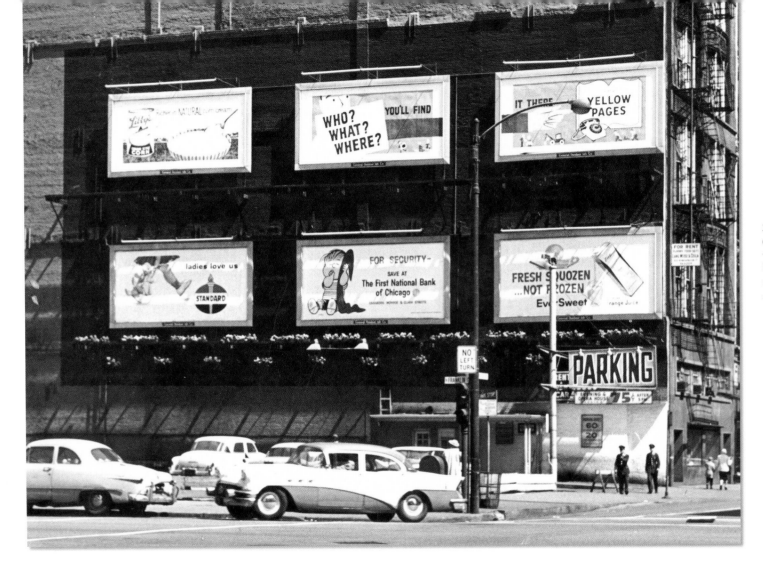

Stacked billboards in Chicago, 1957.

Multiple signs make the most of a building's exterior space.

Welcome to Los Angeles, 1958.

Brooklyn Dodgers president and chief stockholder Walter O'Malley wanted to build a more modern stadium for his ball club. When New York City officials were unable to locate a suitable site, O'Malley announced in late 1957—before 78,672 fans, the largest opening home-game crowd on record—that he was moving the team to Los Angeles Memorial Coliseum. The Coliseum was home to the Dodgers until Dodger Stadium opened in 1962. There is a charm and friendliness to this graphic that reinforces the welcoming message, while nicely incorporating the Dodgers logo.

☜🖅 **Lawrence Welk, 1958.**

Lawrence Welk's "Champagne Music" had achieved popularity throughout the 1930s and '40s playing hotels and nightclubs across the country, as well as on radio. But when he appeared on television from the Aragon Ballroom in Santa Monica during the 1950s, he hit the big time and eventually had his own long-running TV show. Although the champagne bubbles were intended to create a sense of lightness, this board is somewhat static when compared to the highly kinetic Budweiser board.

Pacific Ocean Park, 1958.

Seaside answer to the recently opened Disneyland. Popular during its early years, it closed in 1967.

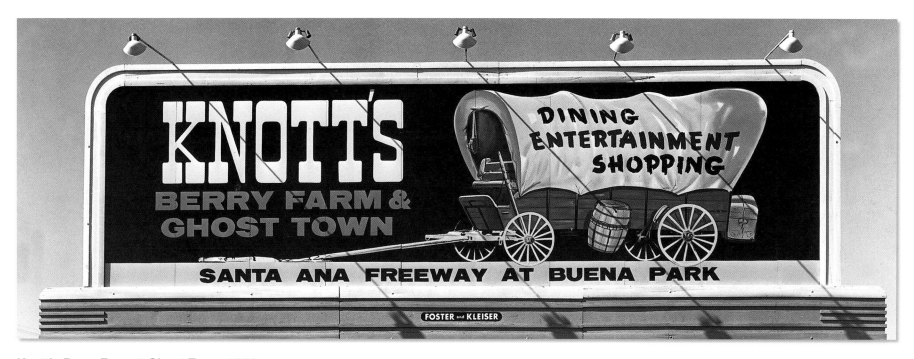

Knott's Berry Farm & Ghost Town, 1959.

Walter Knott cultivated the world's first boysenberries and sold them from a roadside stand in the 1920s. By 1934, Walter's wife, Cordelia, had started serving fried chicken dinners to their produce customers, which became so popular that in 1940 Walter recreated an Old West Ghost Town around their bustling restaurant, using authentic materials and actual structures from real ghost towns. The success of the berry farm and Ghost Town resulted in further expansion of the property, and in 1968 an entry fee was charged for the first time.

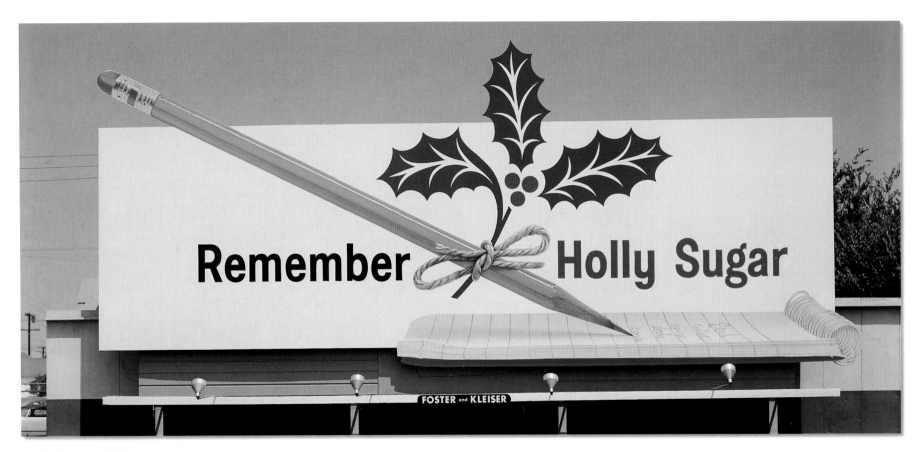

Holly Sugar, 1959.

An exciting graphic that does not display the product it is promoting.

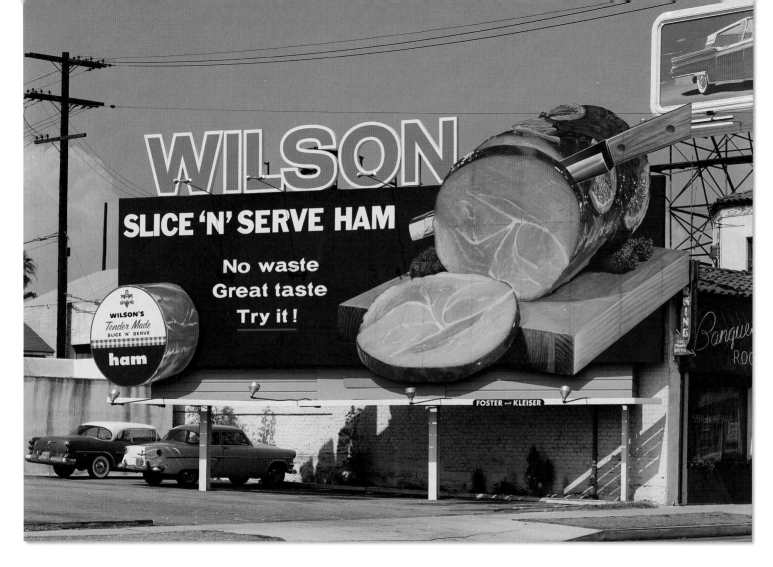

Wilson Ham, 1959.

At the other end of the decade, the Wilson Ham sign provides a 180-degree contrast from the iconic Chevrolet (seen in the upper right-hand corner). It is a complex creation that delivers a great deal of information by giving the viewer's eye many places to dwell.

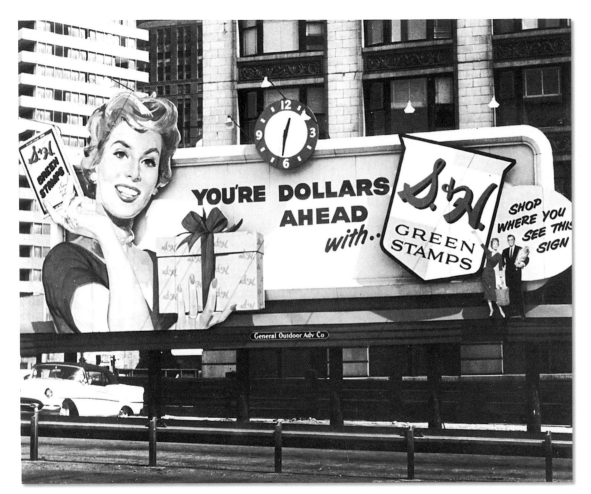

S&H Green Stamps, 1959.

In 1896, the Sperry & Hutchinson Company introduced America to the concept of accumulating stamps with every purchase of goods and groceries as a reward system to promote shopper loyalty. The stamps were redeemable for a wide variety of consumer goods as a bonus for cash spent. By the 1960s, so many green stamps were being issued (three times more than the U.S. Post Office) S&H became the largest purchaser of consumer products (for its reward program) in the world.

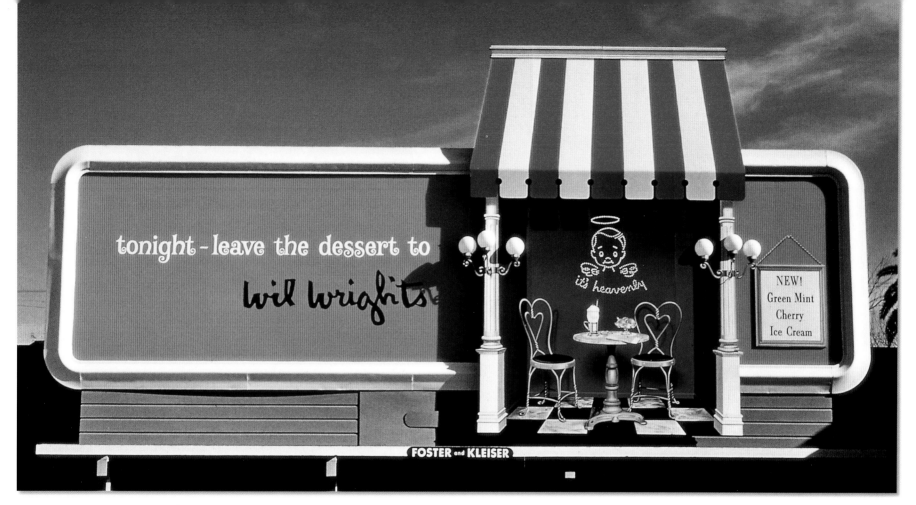

Tonight – Leave the Dessert to Wil Wright's, 1959.

Wil Wright's billboard recreated the popular ice cream parlor's façade.

1960—1969

New Concerns, New Attitudes

The 1960s would be a decade of political upheaval and social contradictions in America, with far-reaching historical consequences like no other: involvement in another unpopular war in Asia, deteriorating relations with the Soviet Union, political assassinations, race riots, violent "peace" protests, the acceleration of the space program, the growth of the civil rights movement, the rise of the drug culture, the birth of the sexual revolution, and the demise of respect for civil authority all were hallmarks of this turbulent time.

America's rivalry with the Soviet Union continued to escalate, bringing the superpowers to a tense stand-off following the now infamous Bay of Pigs debacle. The Cold War grew cooler still with subsequent revelations that the Russians were constructing offensive nuclear missile bases in Cuba capable of striking targets within the United States. Then in 1963, a stunned nation watched and grieved as footage of Kennedy's assassination in Dallas was replayed on television. A few days later, the nation mourned as indelible images of Kennedy's funeral brought the country to a standstill. Before the decade ended, assassins'

bullets would also claim the lives Kennedy's brother and presidential hopeful, Robert, and civil rights leader Martin Luther King, Jr.

Much like the Korean War a decade earlier, what had begun as a commitment to counter a Communist takeover in South Vietnam grew to become the third most costly war in U.S. history. As young men were drafted and casualties mounted, students demonstrated against "the Establishment" on college campuses across the country. Posters and bumper stickers boldly proclaimed "Girls say yes to boys who said no," and exhorted Americans to "Make love not war." Due to widespread antiwar feeling, advertisers steered clear of the patriotic or pro-military themes that had been such effective promotional tools during World War II.

By contrast, the prevalent theme in advertising was humor, from charm and whimsy to clever plays on words and images. As the decade advanced, billboards often reflected trends in photography and fine arts, including pop art, op art, and psychedelic art inspired by the growing counterculture. Social scientists identified a generation gap,

an age-oriented barrier that divided families and polarized the political, corporate, and academic worlds. And it was in advertising that this gap was bridged more effectively and successfully than perhaps anywhere else in the culture.

Why? Because despite its inherently conservative (corporate) origins, the best and the brightest in advertising were highly creative people who had to anticipate what was to come, recognize what was current, and reinterpret what had come before—all while appealing to the widest possible audience. Thus, advertising had become adept at steering a middle course between an Establishment trying to reassert the values of stability and control, and a youth movement bent on shock and controversy.

Kennedy for President, 1960.

Friday, Nov. 22, 1963. ☞

No name. No photo. Only a date. But it was a date that needed no explanation.

☞▌ Ma! White King, 1960.

When It Rains It Pours, 1960.

Morton's advertising campaign offered a light departure from its classic "When it rains it pours" slogan, created in 1911. Their iconic Umbrella Girl, updated over the years, first appeared in 1914.

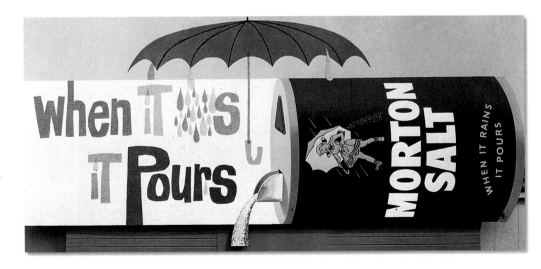

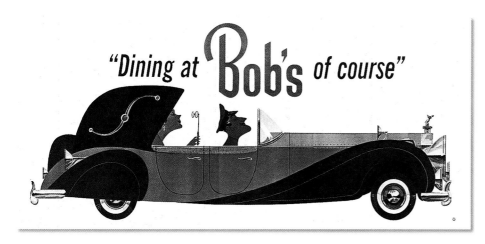

☞ Dining at Bob's Of Course, 1961.

Draggin? Take a Tirend, 1962.

Ironic humor was an important and successful trend in billboard ads throughout the '60s.

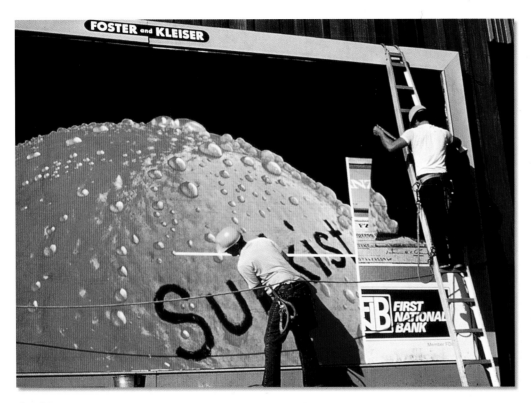

Sunkist, 1962.

The lithographic sheets are pre-pasted, positioned, then brushed into place on the 12 x 25-foot display surface.

Billboard painter, 1962.

Working from a client's finished artwork, he duplicates the image to the full size of a painted billboard. The original image was first projected onto the board's prepared surface at hundreds of times actual size.

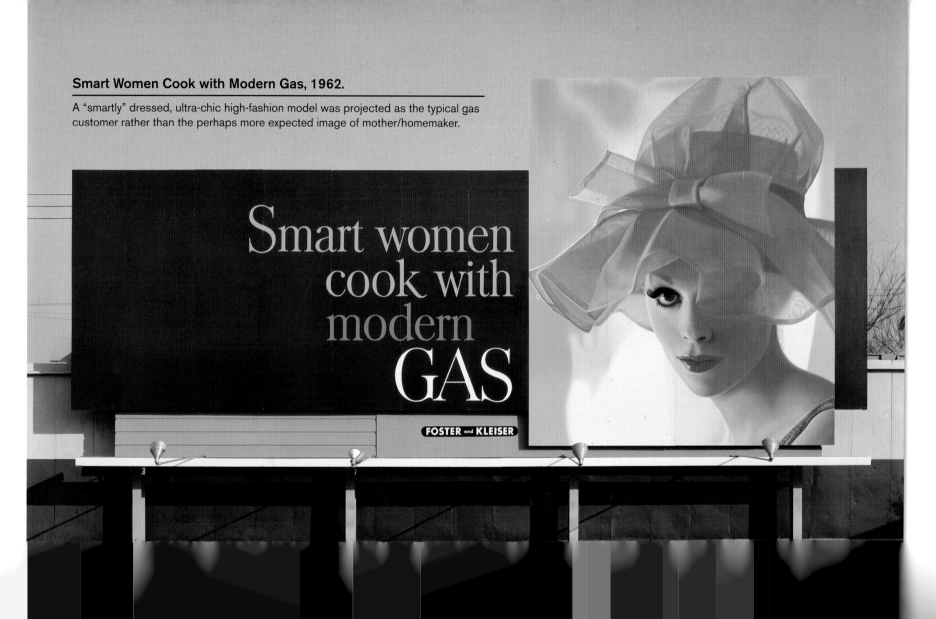

Smart Women Cook with Modern Gas, 1962.

A "smartly" dressed, ultra-chic high-fashion model was projected as the typical gas customer rather than the perhaps more expected image of mother/homemaker.

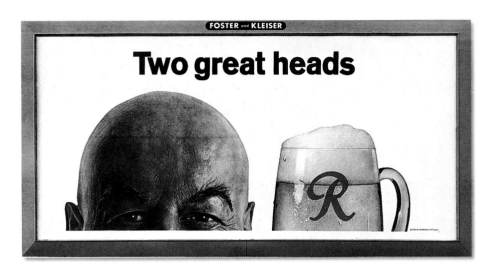

Two Great Heads, 1963.

In the early '60s, few men, and even fewer celebrities, shaved their heads. So the gimmick here was not "who is it?" as everyone knew it was Telly Savalas. The plays on words and images were really directed at the beer and its somewhat cryptic logo. (Although Rainier brand had been famous in the Pacific Northwest for generations, it was less well-known elsewhere in the States.)

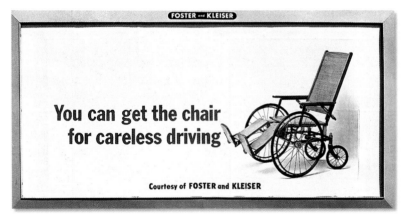

You Can Get the Chair, 1963.

Another visual and verbal pun, but this one with a decidedly serious intent.

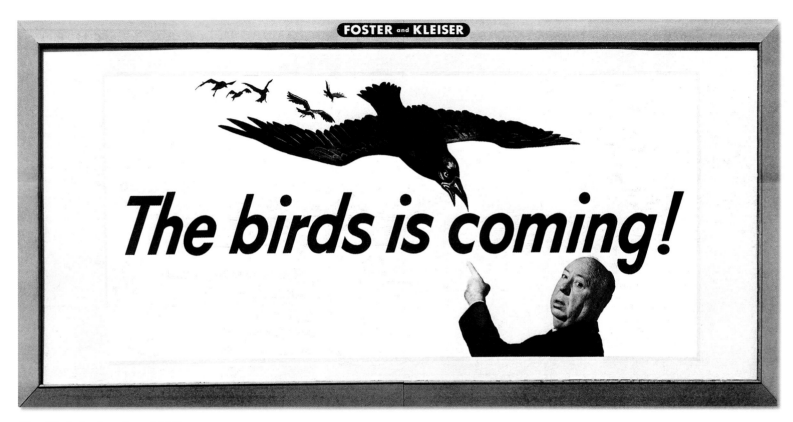

The Birds Is Coming, 1963.

A highly successful movie campaign that not only attracted attention but had viewers thinking. The tagline, at first glance, appeared to be grammatically wrong. But "the birds" referred to the film title, not a flock.

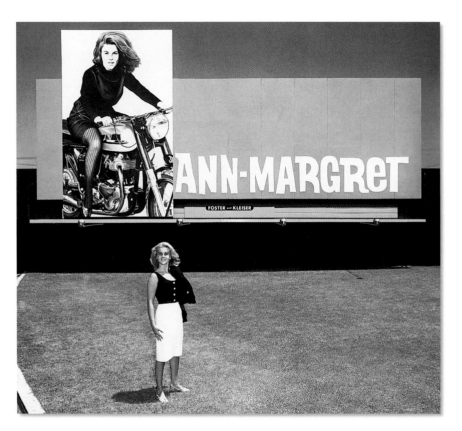

Ann-Margret, 1964.

The actress poses in front of a "teaser" billboard for her movie, *Kitten with a Whip*.

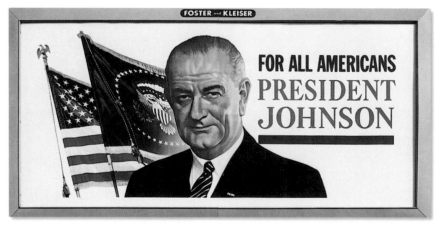

For All Americans–President Johnson, 1964.

Lyndon Johnson came to the presidency following the assassination of John F. Kennedy. Running as the incumbent against the senator from Arizona (opposite), Johnson won.

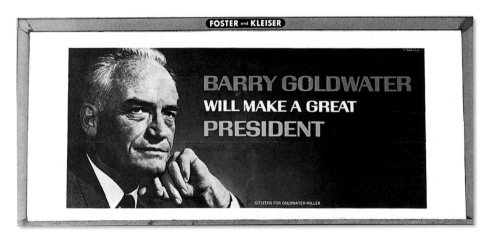

Barry Goldwater Will Make a Great President, 1964.

Johnny Mathis, 1965. ☞

The pop singer and balladeer stands before a Sunset Strip
billboard promoting his latest album.

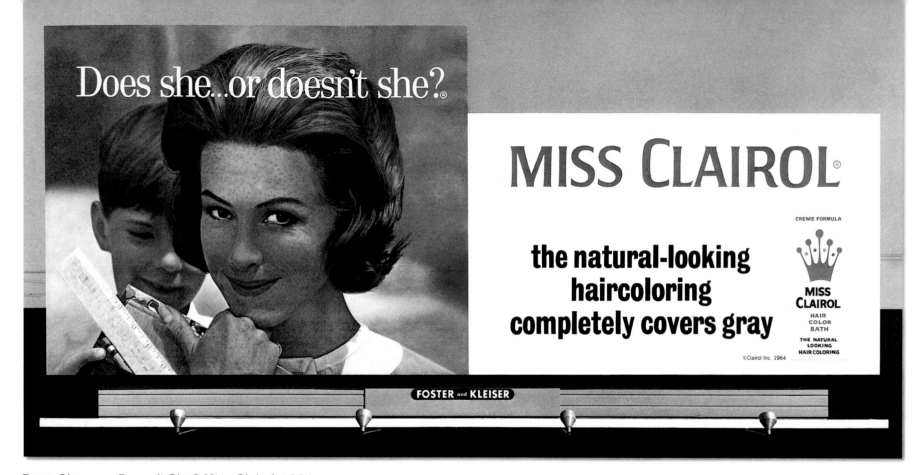

Does She. . . or Doesn't She? Miss Clairol, 1964.

Introduced in 1957, this Clairol campaign has been ranked among the top ten of all time. What made it so effective? It turned the premise of promotion upside down by suggesting that *not* knowing if a customer used a product was better than knowing.

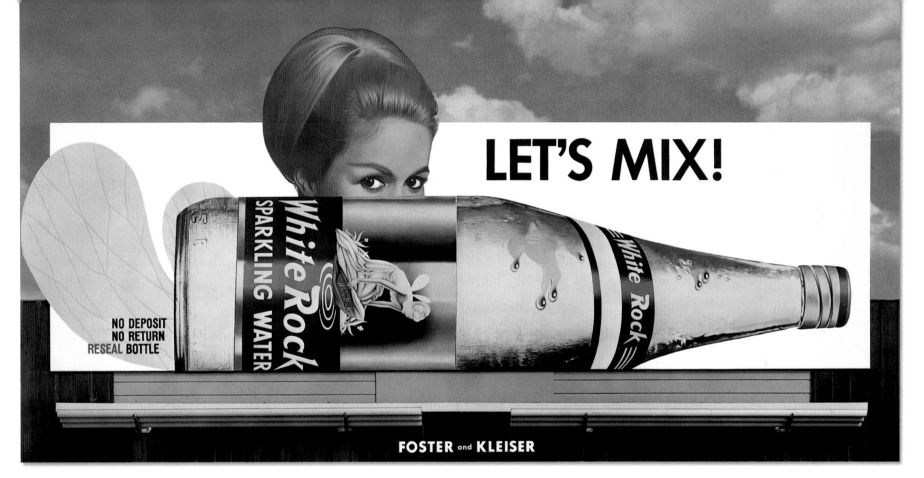

Let's Mix! 1967.

Psyche, the White Rock girl since 1893, got a makeover periodically to keep her image fresh. An updated '60s counterpart peers over a bottle of sparkling water that still bears a label with her nineteenth-century likeness.

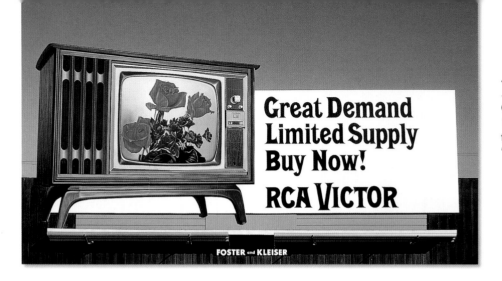

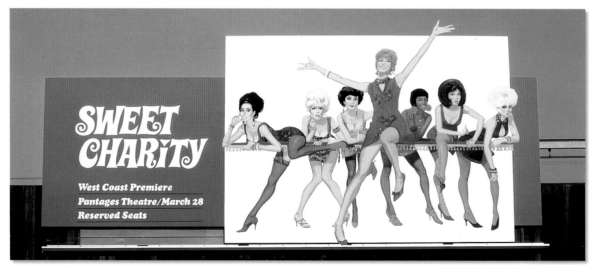

☞ Great Demand, Limited Supply, Buy Now, 1967.

Color television had been around for years, but it wasn't until 1966 that the networks began to broadcast in color nightly—and the rush to buy color sets was on. This campaign used the ploy of "limited stock" to create a sense of urgency.

Sweet Charity, 1969.

Small spender.

Small Spender, 1968.

One in a series of popular billboards for Volkswagen, which won the Award of Excellence for its outdoor campaign, the message overlapped with the promotion for the film *Sweet Charity*,1969, which featured a show-stopping number titled "Big Spender."

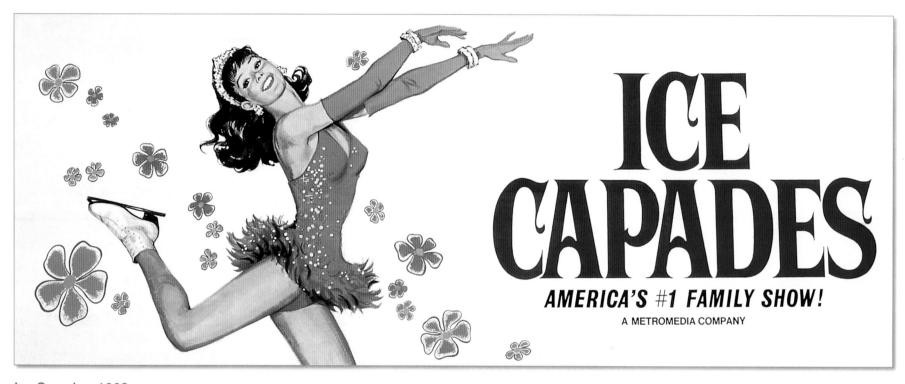

Ice Capades, 1968.

It's probably no accident that this model bears a resemblance to 1964 Olympic gold medallist Peggy Fleming, who attracted more attention to figure skating than anyone since Sonja Henie.

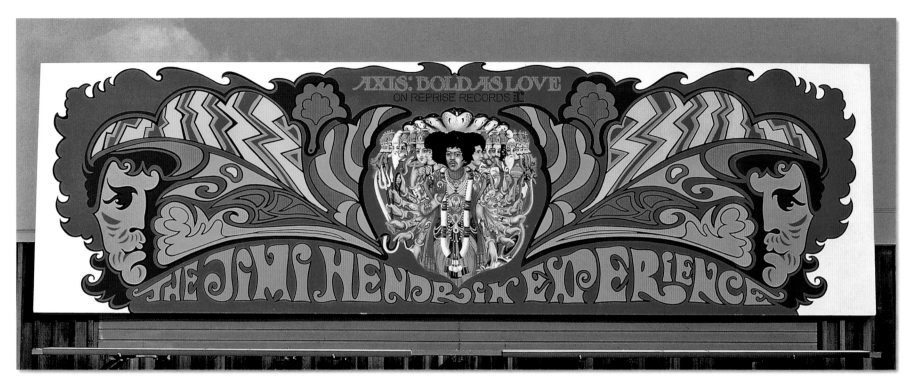

The Jimi Hendrix Experience, 1968.

Psychedelic art met Madison Avenue and arrived on the Sunset Strip, heralding the peak year for this hugely influential musician with sell-out concerts and two gold albums.

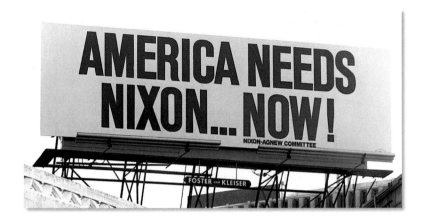

👉 America Needs Nixon, 1968.

After a narrow defeat to Kennedy in the 1960 presidential race, Nixon ran again, this time against Hubert Humphrey, and was elected the 37th President of the United States.

Gov. Reagan Says: "Taxes Should Hurt," 1968.

The Committee for Fair Taxes sponsored this billboard.

Pan Am, 1969.

This time a visual pun demonstrates simplicity and creativity at its best.

**Watch Our Stewardess ☞
Cut Up, 1968.**

Despite the obviously humorous intent of the visual and verbal pun, this campaign would never be considered for an airline promotion today.

Watch our stewardess cut up.

In First Class.

American Airlines to New York

☞ Gang Up on Thirst, 1968.

Foreshortened perspective is heightened by the cutout extensions. The soft drink wars were underway and fierce competition made for some very creative ad campaigns.

We Keep Wet Baby Bottoms . . . , 1969.

☞ **Barbra, 1969.**

Who else but superstar Barbra Streisand, fresh from winning an Academy Award for *Funny Girl,* could away without using a last name?

The Beatles were so famous by the end of the '60s, no name at all was needed on this teaser for the *Abbey Road* album, 1969.

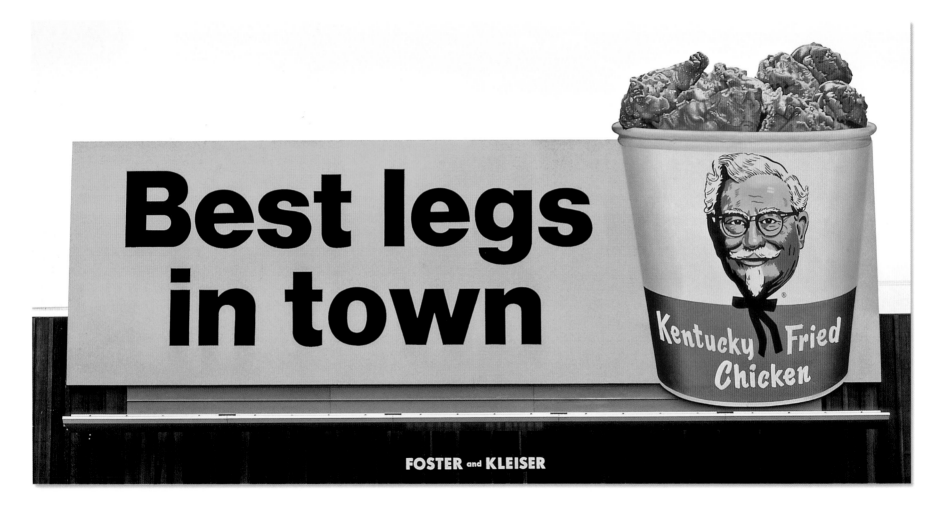

Big Mac, 1969.

Giant burger takes on even greater proportions when seen next to a billboard painter as he retouches the artwork prior to an installation for McDonald's.

Best Legs in Town, 1969.

Colonel Harlan Sanders began serving fried chicken at his restaurant, Sanders Court & Café in Corbin, Kentucky, during the late 1930s. In 1952, he franchised his business. Fifteen years later more than 600 KFC outlets had opened across the U.S. and Canada. The play on words in this campaign was placed with what had already become an instantly recognizable symbol—thanks to nearly twenty years of successful branding.

1970—1979

Reawakening & Transition

The momentous events of the 1960s were followed by another decade of political and social upheaval. Escalation of the Vietnam War ignited more antiwar demonstrations on over 400 college campuses across the country, the most deadly occurring at Kent State University in Ohio. Early in 1973 the U.S. finally began its withdrawal as President Richard Nixon claimed that "peace with honor" had been achieved. But with the fighting continuing even as helicopters lifted off the roof of the American embassy in Saigon, there was no real peace. And given the $150 billion price tag and the loss of more than 57,000 lives to a cause they neither fully understood nor supported, for the majority of Americans there was no honor.

And there was more. The OPEC oil embargo halted crude oil shipments to the United States and Europe, forcing a precipitous rise in gas prices, long lines, and even rationing at the pumps. A break-in at the National Democratic Party headquarters at the Watergate complex in Washington, D.C., led to the eventual impeachment of President Nixon for his involvement in the conspiracy and subsequent cover-up. Faith was further eroded by a nationwide "recession" across corporate America, precipitating massive lay-offs, and creating the first economic depression since the 1930s. Thus, in 1976 the nation's 200th birthday was celebrated amid a decade marred by disillusionment and disappointment.

Turned off by the headlines they felt impotent to influence, many Americans turned inward instead. The 1970s became known as the "Me" decade, a label coined by social critic and novelist Tom Wolfe, as Americans sought spiritual awakening, personal fulfillment, and physical renewal. They turned to Eastern religion, self-help books, fad dieting, aerobic exercise, personal therapy, and sex. By the 1970s the sexual revolution was in full swing (pun intended) and was by no means exclusive to America's youth. Interestingly, the result of all this introspection eventually bore fruit in a number of crucial political arenas, such as the women's movement with the passage of the Equal Rights Amendment and the legalization of abortion, as well as a newly awakened concern about the environment.

For the first time in history, coffee fell from its sovereign position to second place in per capita beverage consumption, and was replaced by soft drinks. Coca-Cola's $200 million annual advertising budget led the charge in the subsequent soda wars. When cigarette advertising was forced off television and radio by consumer groups, cigarette sales *increased* (just as they had a decade earlier), due in part to effective billboard campaigns, such as the iconic Marlboro Man. The oil crisis and subsequent gas shortages had travel industry advertisers shifting to markets closer to home, and had the auto industry moving to the production of smaller cars, with an emphasis on fuel reduction. The 1970s also ushered in an industry still in its infancy: At a consumer electronics convention in Chicago, handheld computer games were the big attraction.

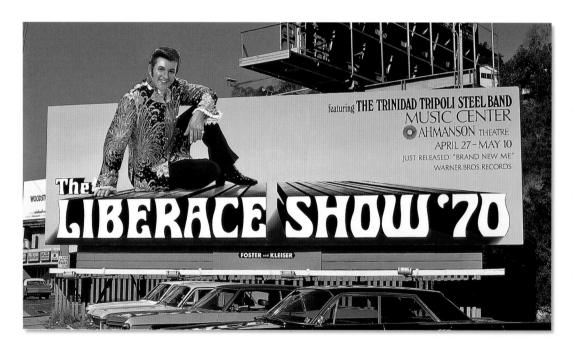

The Liberace Show '70, 1970.

A versatile and classically trained musician, Liberace achieved his greatest success in Las Vegas, where he created an outrageously flamboyant persona that was affectionately known as "Mr. Showmanship."

Only Pendleton Makes Pendleton, 1970.

Extremely complicated design in which thousands of woven woolen strands had to be painstakingly and individually painted to replicate the look of a signature Pendleton plaid.

Every Body Needs Milk, 1970.

In 1974, the Federal Trade Commission cited the California Milk Producers advisory board and its ad agency for its popular slogan, "Every Body Needs Milk," as representing false, misleading, and deceptive advertising. It was subsequently changed to "Milk Has Something for Every Body," and paired with the wholesome image of Florence Henderson who was enjoying enormous popularity as Carol Brady on the hit television show, *The Brady Bunch,* which ran from 1969 to 1974.

Nancy, 1970.

Singer Nancy Sinatra visited her billboard for a final once-over before it went up.

It's Boss. It's Groovy. It's Bowling, 1970.

A traditionally conservative pastime was given a hip new image through the use of a nontraditional color and unconventional vernacular.

Neighborhood Watch, 1971.

Thousands of permanent signs (smaller versions of the big public service boards) bearing the distinctive Neighborhood Watch icon still dot urban and suburban areas all over the country today.

Help Us Help You, 1971.

Smokey the Bear, one of America's most recognized animal icons, was created in 1945 shortly after a ranger found an injured, orphaned bear cub in the aftermath of a forest fire. Nursed back to health and named Smokey, he became the model, or "spokesbear," for a nationwide forest fire prevention campaign. McGruff, the Crime Dog, joined Smokey for this 1971 promotion that urged corporations to continue supporting the Outdoor Advertising Association of America (founded in 1942) so that it (OAAA) in turn could serve the public interest.

The Mark Is Tops, 1972.

A new take on the renowned Top of the Mark, the rooftop restaurant at San Francisco's Hotel Mark Hopkins.

Ford, 1972.

Ford customized this billboard for regional sales in the Cincinnati area, home to the Cincinnati Reds, who won the 1972 World Series and went on to dominate the National League throughout the '70s.

☛ Good Fun, Carnation Ice Cream, 1972.

Conserve Energy, 1973. ☞

Boom truck, equipped with a large crane, was introduced in the 1950s and made for easier installation to higher elevations, even rooftops. Removable painted boards (installed in panels, not unlike the multi-sheet poster boards from the 1920s), usually remained at one location for thirty days, and were then disassembled and rotated to other locations for maximum exposure.

☞ **7-Up, 1974.**

Seven years after 7-Up introduced its "UnCola" campaign, the company unveiled another whimsical concept: spelling out the product name in smoke from a biplane. Aerial "billboards," using vapor or banners, had been popular for decades, and this example lent nostalgic charm to the serious competition for consumer soft drink dollars.

Wet un Wild, 1970.

7-Up exploited the Pop Art influences of artist Peter Maxx and the animated Beatles film *Yellow Submarine* in its hugely successful UnCola campaign launched in 1968.

Grateful Dead from the Mars Hotel, 1974.

Advertisers knew the surrealistic "message" would be clear to fans, affectionately known as "deadheads."

👉 **Benson & Hedges 100's, 1974.**

With cigarette commercials banned from television and radio, and the dangers of smoking out in the open, the tobacco industry had to redirect its promotional efforts of new products. Benson & Hedges tried to shift their previous message of adult sophistication to one of friendly innocence, and what could be more benign than a clown?

Meet the Turk, 1975.

Also looking for an image makeover, "He smokes for pleasure" was a clear counter-argument to the news that smoking was not only addictive but potentially deadly.

The Snack Bar from Dole, 1975.

The tried-and-true visual pun pioneered in the 1960s was going strong throughout the '70s.

☜ **A Different Set of Jaws, poster, 1975.**

Sexy spoof of sci-fi horror films, based on a rock musical, failed at the box office, but has since become a huge cult favorite. The tagline was, of course, referencing the '70s box office champion *Jaws*.

Will O' the Wisp, 1975.

Sunset Strip billboard for the Leon Russell album. The sign does not exploit the elongated billboard shape, but rather deliberately maintains the square LP artwork, thus reinforcing in visual terms that the item is a record.

There's No Place Like America Today, 1975.

Crafted to tie-in with the nation's upcoming bicentennial, and aimed at middle-class Americans, this board was intended to bolster sagging patriotism through the use of nostalgic imagery.

Now for the Next 200, 1976.

America celebrated its 200th birthday on July 4th, 1976. Due to the overwhelming disillusionment of the time, it is no accident that Uncle Sam has to do some heavy lifting to drum up support for the bicentennial, and beyond.

☜ Lake Tahoe's Winning Combination, 1976.

Trapezoid-shaped panels create the optical illusion of an unfolding billboard, not unlike a travel brochure, but on a gigantic scale.

Arlington Park, 1976.

Not intended for a national audience, this highly stylized board was aimed at Illinois residents who needed no labeling to recognize Chicago's premier racetrack.

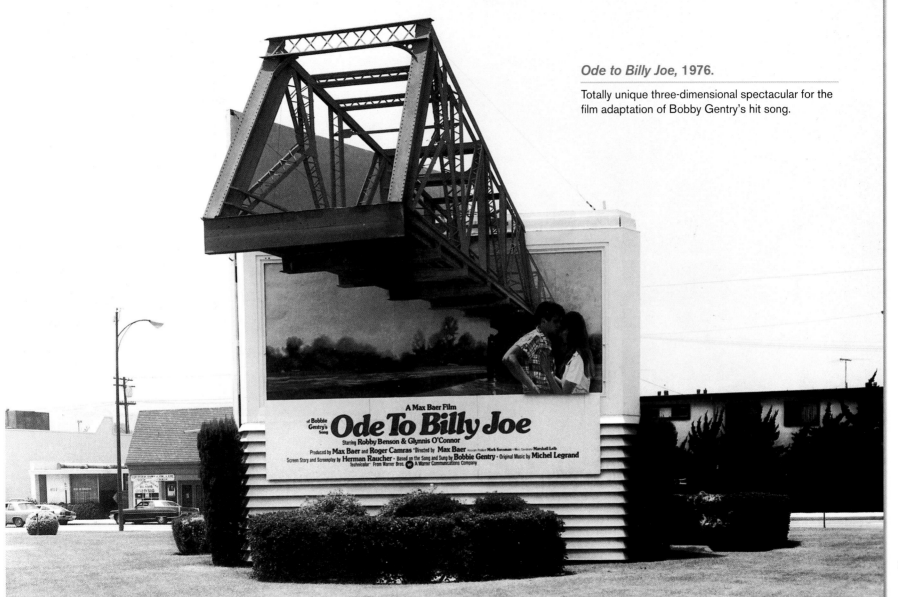

Ode to Billy Joe, **1976.**

Totally unique three-dimensional spectacular for the film adaptation of Bobby Gentry's hit song.

189

Unleashed–San Diego Wild Animal Park, 1976.

A highly detailed, beautifully rendered eagle alerted both locals and visitors to one of Southern California's major attractions.

Las Vegas–New Flamingo Is Wild, 1976.

World's Leading Suntan Notion, Palm Springs, 1978.

The play on words campaigns that were so successful throughout the 1960s grew more provocative during the 1970s. Tight cropping on the reclining figure and the hand contributes to the suggestive sexiness of the ad. Many cities throughout the U. S. were successfully promoting themselves as resort destinations, thanks to the oil crisis and subsequent fuel shortages of the early '70s, which made long-distance travel more expensive.

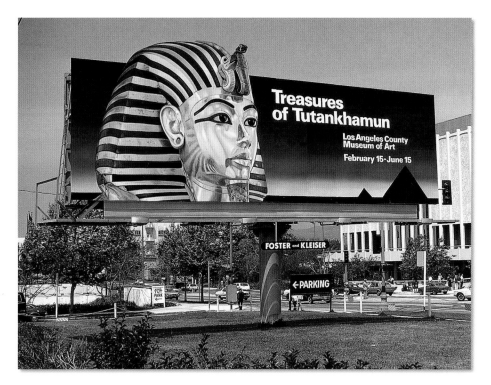

Treasures of Tutankhamun, 1978.

With the museum directly across the street, this billboard for the long-awaited King Tut exhibition became, in effect, a point-of-purchase promotion.

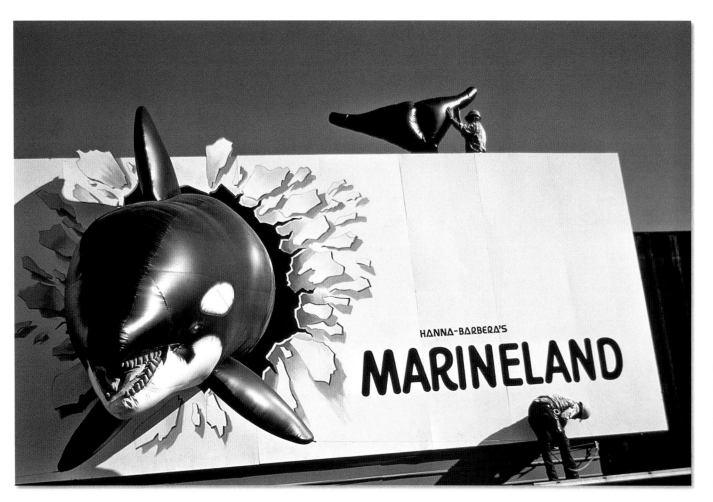

Marineland, 1979.

Orca the killer whale appears to leap through the billboard during its installation. Made of vinyl-coated nylon, the whale was kept inflated by small computer-operated fans throughout the duration of this innovative three-dimensional display.

Raquel, 1979.

Following in the footsteps of other pin-ups girls, like Betty Grable, Raquel Welch went from 1960s movie sex goddess to a star in her own Las Vegas nightclub act, performing before standing-room-only crowds.

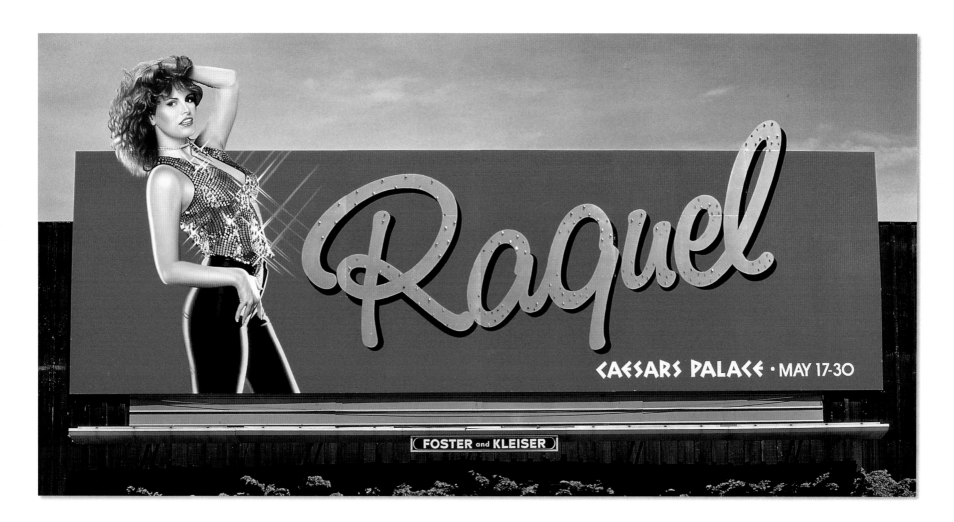

1980—1989

Bigger, Brighter, Bolder

Following the years of economic recession, America was ready for a change in fortune. The 1980s proved that not only could the "Me" decade be outdone, it would make the '70s look modest in comparison. Art imitated life as the four top-rated television series—*Dallas*, *Dynasty*, *Knott's Landing*, and *Falcon Crest*—epitomized the self-indulgence of the times through characters that bought, sold, schemed, and slept their way to wealth and power.

Real-life attitudes and values had taken a decidedly acquisitive turn, even among the young. A study by UCLA and the American Council on Education in 1980 reported that incoming college freshmen were more interested in status, power, and money than at any time in recent memory. So much for the innocence and idealism of youth—young urban professionals, "yuppies" had arrived.

Money was the driving force of the decade, and playing the stock market was the preferred modus operandi for getting it. Terms like "leveraged buyout" and "hostile takeover" became part of the vernacular. The first cellular phone system was introduced in Chicago during the '80s, and, as microchip technology came into its own, the personal computer moved inexorably from the workplace into the home office.

Mobile phones, VCRs, designer clothes, imported cars—specifically, BMWs—and cable television, including MTV, and CNN, became indispensable to the yuppie household. Two-income families gradually became and the norm and they paid with credit cards, rather than cash.

Throughout the nearly decade-long Reagan presidency, there were other segments of the population that did not fare as well. Many corporate mergers, while increasing profits for shareholders, meant downsizing and lay-offs for large numbers of blue-collar workers. This, coupled with sweeping cuts in federal and state welfare programs, created a sharp rise in homelessness, the largest since the Great Depression of the 1930s. The decade was also stalked by the AIDS virus, a worldwide pandemic that continues to cross social, racial, and gender barriers to this day.

American women, however, enjoyed unprecedented standing during the 1980s. Sally Ride became the first female astronaut, Sandra Day O'Connor became the first female Supreme Court Justice, and Geraldine Ferraro became the first female vice-presidential candidate. In the business arena, more and more women found themselves climbing the corporate ladder and "breaking the glass ceiling" when they reached the top.

After a four-decade standoff, the '80s saw the U. S. versus U. S. S. R. Cold War begin to thaw, until, in 1989, even the moderate Gorbachev government couldn't survive the Soviet system, which finally collapsed under its own weight. The same year, the Berlin wall that separated capitalist West Germany from communist East Germany was dismantled. By the start of the new decade, the Iron Curtain between Eastern and Western Europe had, at last, come down.

Cher, 1980.

Cher's Ceasars Palace billboard continued the trend, begun in the 1960s, of using an entertainer's name only, with no supporting copy, to promote their nightclub act.

Don't let Your Rights Erode, 1981.

The ACLU employed the same promotional tactics that were used so successfully on billboards throughout World War II.

Expose Yourself to Something New, 1981.

If you didn't know the Chippendales were male strippers, then you didn't get the play on words. But in that case, you were probably living on Mars.

Pink Floyd–*The Wall,* 1983.

Sunset Strip promotion for the video release of the 1982 film based on the chart-topping album. Although many pop and rock musicians had been filming their performances for years, the phenomenon of the music video–a scripted and choreographed filmed interpretation of a song made for the sole purpose of promoting an album–was still a relatively new idea.

Rampage, 1983.

As lithographic sheets were pre-pasted, positioned, and brushed onto the 12 x 24-foot display surface, the Ford truck would appear in a matter of hours.

The Maryland horse industry let its colorful and highly stylized logo do most of the work of conveying the speed and power of thoroughbred racing.

Fresh and Refresh, 1983. ☞

Every bit as colorful, Sizzler chose a different approach, using the heightened realism of photography to convey the just-picked juiciness of its salad bar components.

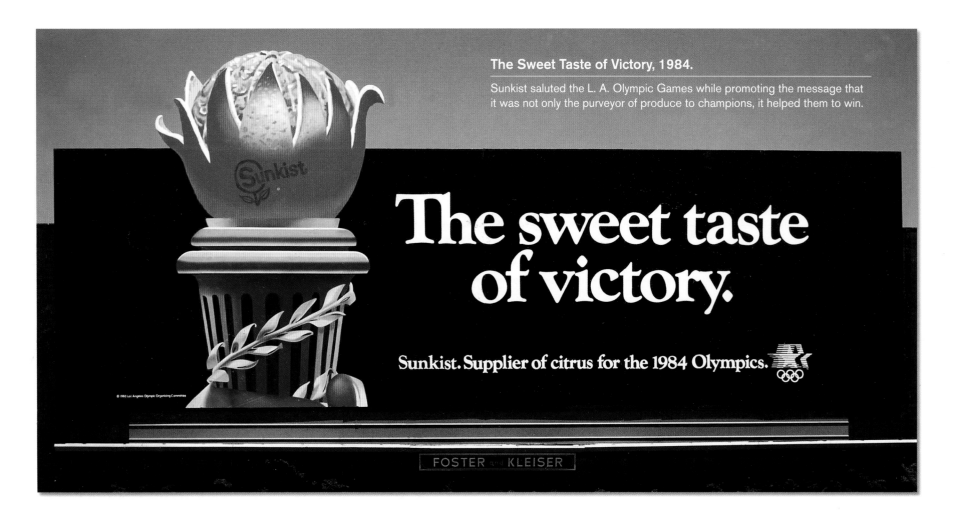

The Sweet Taste of Victory, 1984.

Sunkist saluted the L. A. Olympic Games while promoting the message that it was not only the purveyor of produce to champions, it helped them to win.

The sweet taste of victory.

Sunkist. Supplier of citrus for the 1984 Olympics.

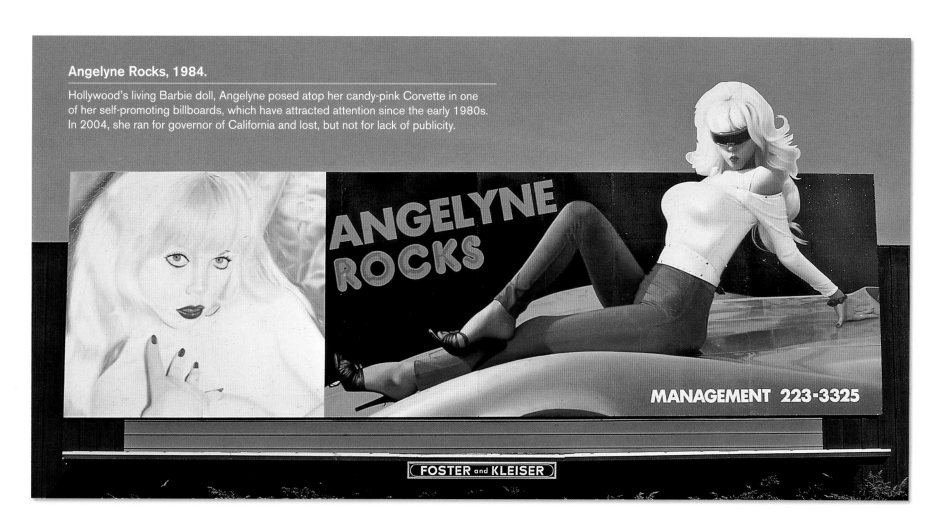

Angelyne Rocks, 1984.

Hollywood's living Barbie doll, Angelyne posed atop her candy-pink Corvette in one of her self-promoting billboards, which have attracted attention since the early 1980s. In 2004, she ran for governor of California and lost, but not for lack of publicity.

ANGELYNE ROCKS

MANAGEMENT 223-3325

FOSTER and KLEISER

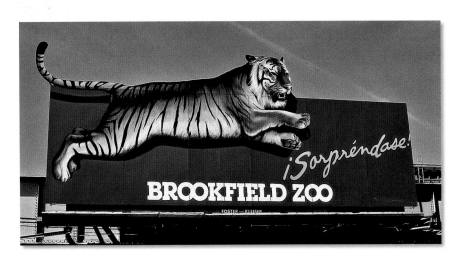

Brookfield Zoo, 1985.

Chicago's Brookfield Zoo gained international acclaim soon after opening in 1934. A basically "barless" or "cageless" zoo, visitors were separated from animals by a moat built around each "habitat," a trend that would eventually become the industry standard for zoo design throughout the world. The leaping tiger paired with the Spanish word for "Surprise!" reinforce the free-roaming approach pioneered by the Brookfield.

Gatorade, 1985.

The perspiration-drenched model evokes the conditions under which Gatorade was created: the University of Florida developed the drink in 1965 to help its football team prevent dehydration while playing in extreme humidity.

Shu Uemura Beauty Boutique, 1988.

The arrangement of lipsticks, eye shadows, and make up brushes, is subtly reminiscent of an artist's palette. The message, while not overt, is still clear: the customer's face will become the work of art.

Les Miserables, 1987.

Monumental wrap-around spectacular for the March 12, 1987, opening of "Les Miz" at the Broadway Theater; the show ran for 6,680 performances before closing on May 8, 2003. The iconic image of the child Cosette, with the French tricolor flowing though her hair, is among the most immediately and widely recognized theatrical images of all time.

1990–1999

A New Era Begins

As America entered the last decade of the millennium, the economy again began to slip toward recession. In 1991, the First Gulf War did little to reverse the economic slowdown. However, for the first time in more than a quarter-century, the U.S. armed forces began to actively recruit through media advertising. Broadcast and print campaigns included, "Be all that you can be, in the Army." and "The proud. The few. The Marines."

As Bill Clinton headed for the White House in 1992, high-tech firms were driving the economy steadily upward to unprecedented heights. The World Wide Web, now known simply as the Internet, was born in '92 and millions of people went online. Microchip and cellular technology made personal computers, cell phones, and indeed all electronics smaller, smarter, faster, and more powerful. Americans learned to communicate, share information, and do business with each other, and with the world, in a new and instantaneous way. By 1994, the day of the dot coms had dawned as small Internet start-up companies went public and became overnight sensations.

The economy continued to thrive throughout the decade, despite U.S. troop deployment to Haiti and Yugoslavia, racial violence in south central Los Angeles, the bombing at the Alfred P. Murrah Federal Building in Oklahoma City, the first bombing beneath the World Trade Center in New York, deadly shootings at Columbine High School in Littleton, Colorado, sex scandals within the Clinton administration, and once again talk of a presidential impeachment.

There were rumblings within the advertising world as well, particularly for the tobacco industry. Cigarette promotion had been controversial since the early 1950s, due to the awareness of the health risks associated with smoking. In 1990, California launched a statewide antismoking billboard campaign. And by 1998, cigarette promotions were forced off billboards for good.

In advertising, images began to take precedence over text, and symbols over slogans. Consumer demographics revealed younger markets with disposable income that more readily responded to visuals, having been raised with television and computer games.

Vinyl had revolutionized the outdoor advertising industry when it was introduced during the 1980s. Until the '90s, however, most billboards were hand-painted on heavy plywood that faded and chipped with time and weather. Technology developed at MIT all but eliminated the professional sign painter. The once labor-intensive procedure was replaced by a digital imaging process that enlarged and transferred the artwork, assuring faithful reproduction of even enormous graphics. Digitally printed on durable, weather-resistant vinyl that could be cut to any size, the signs were rolled and wrapped for easy shipping and installation. (Today, the flexible vinyl facing of discarded billboards is being reclaimed and reused by artists as canvases for indoor-outdoor art.)

Just as the new boards were being introduced it was reported that many consumers felt so bombarded by media advertising, they no longer paid attention. As the twenty-first century neared, subtle and not-so-subtle approaches were tried in a desperate bid to capture an audience already jaded from too much input. Ads began to appear almost everywhere eyes could see: buses were literally wrapped in ads, brand names and logos appeared on shoes, jewelry, clothing, and underwear; product placement in films and television became increasingly competitive; blinking aisle displays appeared in supermarkets; and promotions have even appeared on the space shuttle!

At the close of the twentieth century, the United States, along with the whole world, celebrated the start of the new millennium. But within a year, September 11 would overshadow any other date in modern American history as the skies over the Pentagon and the Twin Towers of the World Trade Center burned, not with fireworks, but with jet fuel.

Caesars Palace, 1990.

Outdoor spectacular for the lavish Las Vegas hotel captures the spirit of ancient Rome. The painted charioteer holds actual reins and wields a three-dimensional whip in his hands. Prior to the hotel's 1967 opening, owner Jay Sarno insisted the apostrophe be dropped from "Caesar's" because it would intimate "it was a place of only one Caesar." He wanted to create the feeling that all the hotel's guests were royalty.

☞ **Cruise Like Thunder, 1990.**

Masterful use of fiery colors with time-lapse imagery on polarized film ignite this deceptively simple billboard for *Days of Thunder*. By 1990, Tom Cruise was such a megastar, neither his first name, nor the movie's title was necessary.

Los Angeles Marathon VI, 1991.

The inaugural Los Angeles Marathon was held in 1986 to reinforce the spirit of camaraderie within the city following the Olympic Games, held two years earlier.

See The First and Fairest of them All.

WALT DISNEY'S CLASSIC

Snow White and the Seven Dwarfs

July 2. At Theatres Everywhere

Snow White and the Seven Dwarfs, 1993.

The billboard for the rerelease of Disney's beloved 1937 classic reminds viewers that it was the first full-length animated Technicolor feature in history—and that it's still the best.

GET MET. IT PAYS.

❋ MetLife

Get Met. It Pays, 1995.

Charles Schulz's perennially popular *Peanuts* characters, Snoopy and Woodstock (among others), starred in a hugely successful and endearing MetLife campaign.

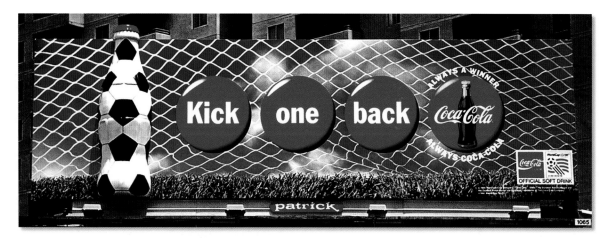

☜ Kick One Back, 1994.

There's no mistaking Coke's tie-in as the official soft drink for the Soccer World Cup.

Stay Cool,1997.

Miller Genuine Draft created a kinetic energy effect similar to the Budweiser campaign from 1954 (see page 137).

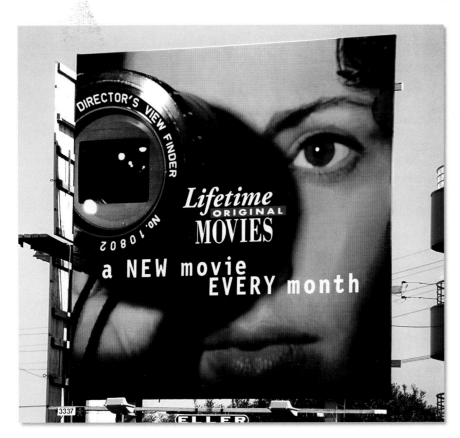

A New Movie Every Month, 1997.

New billboard shapes and sizes were introduced to take advantage of available display spaces.

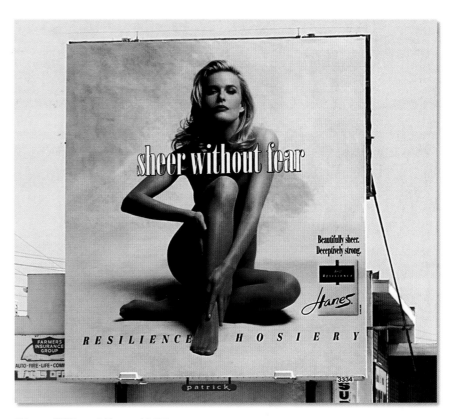

Sheer Without Fear, 1997.

The cool gaze of this model echoes the bold bathing beauty from the Onyx Hosiery poster (see page 18). Even after more than ninety years, sex appeal never goes out of style.

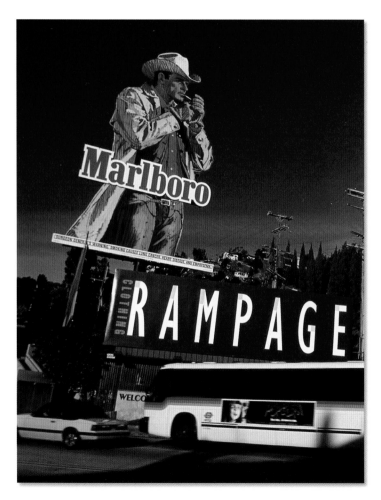

Our Philosophy Since 1937, 1997.

Delightfully literal visual means that this Mercedes-Benz dealership doesn't have to spell out the fact they've been bending over backwards for their customers for sixty years.

👉 **The Marlboro Man, 1998.**

The Sunset Strip's famous cowboy billboard was literally hauled off into the sunset on March 9, 1999, as part of a multi-million dollar settlement by tobacco producers. Various incarnations of the 70-foot Marlboro Man had stood tall in the same location for seventeen years.

We Will Never Forget, 2001.

One of many New York tributes to the fallen heroes of the 9/11 attack. This handmade poster is protected from the elements by a sheet of flexible plastic so it can hang year-round on the firehouse door.

Hollywood, 2000.

Perhaps the most recognized sign on Earth, it is, in fact, a series of billboards, making it the world's longest and largest outdoor sign. Measuring 450 feet in length with letters 45 feet high, the sign is located atop Mt. Lee, the tallest peak in Los Angeles. The sign was even larger when it was erected in 1923 as a promotion for a real estate development called Hollywoodland. The last four letters were removed in 1945.

Afterword

The latest advancement in outdoor signage are the Internet–connected digital displays, a developing medium of video graphic and message boards with which text and image content can be updated or replaced by a few keyboard strokes on digital screens of any size or shape. The OAAA estimates that advertisers spent a staggering $6.3 billion on outdoor promotions in 2005, and with the enormous flexibility afforded by the new cutting-edge technology, the applications are virtually limitless. All of which means that outdoor advertising is once again in demand by America's image-makers and is, thankfully, here to stay.

Artkraft Strauss, the company that made the glittering spectaculars that once lit up Times Square, announced in May 2006 an auction featuring a large collection of its drawings, lights, and neon signs. "It seems like a good time," said Tama Starr, who follows her father and grandfather as head of the firm. "People are interested in this kind of artifact. It's representative of an art form that is not being made much anymore." An art form, indeed.

TBS Very Funny, 2005.

Sex and the City star Sarah Jessica Parker looks down on Los Angeles from her lofty tallboard perch.